IMAGES
of America

TUCKER'S ISLAND

Deborah C. Whitcraft

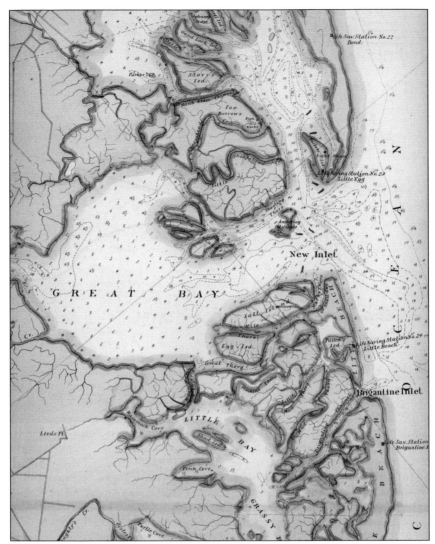

This 1878 map shows coastal islands that wrap around the entrance of Great Bay. Just above center right is Tucker's Island, behind Tucker's Beach. "New Inlet" is clearly marked on this map (center right). Most of the coastal islands were not inhabited, but life on Tucker's Island was vital and industrious. Those on the island were led by the brave men of the Rider family, including lightkeeper Eber Sr., lightkeeper Arthur Rider, and station keeper Jarvis Rider. There was a sense of pride among those who served in the US Life-Saving Service and, in spite of the hardships encountered, families who lived on the island were content. (New Jersey Maritime Museum.)

On the Cover: Little Egg Harbor Life-Saving Station keeper Jarvis Rider began his job at the age of 20, starting out as a paid keeper in 1869 and continuing at his post for 46 years. His tenure was the longest in the history of the US Life-Saving Service. Respectfully referred to as "Captain," Rider, with hat, tie, and dark pants, is the short man in the middle of the group of three men. It is estimated that Rider and his surfmen saved $2.3 million worth of vessels and cargoes over the years. The Little Egg Station was a typical Jersey-type station with an octagonal tower and peaked roof. (New Jersey Maritime Museum.)

IMAGES
of America

TUCKER'S ISLAND

Gretchen F. Coyle and
Deborah C. Whitcraft

ARCADIA
PUBLISHING

Copyright © 2015 by Gretchen F. Coyle and Deborah C. Whitcraft
ISBN 978-1-4671-3376-0

Published by Arcadia Publishing
Charleston, South Carolina

Printed in the United States of America

Library of Congress Control Number: 2015933197

For all general information, please contact Arcadia Publishing:
Telephone 843-853-2070
Fax 843-853-0044
E-mail sales@arcadiapublishing.com
For customer service and orders:
Toll-Free 1-888-313-2665

Visit us on the Internet at www.arcadiapublishing.com

Tucker's Island is dedicated to the inner child in all of us—the wonderers, wanderers, explorers, and adventurers.

CONTENTS

Acknowledgments 6

Introduction 7

1. Little Egg Harbor (Tucker's Island) Lighthouse 11

2. Lightkeepers Eber Rider and Arthur Rider 23

3. The Columbia and St. Albans Hotels at Sea Haven 31

4. Life on Tucker's Island 37

5. A Cast of Characters 59

6. US Life-Saving Service/Coast Guard Station 75

7. A School and Scammers 89

8. Going, Going, Gone in October 1927 103

9. Shipwrecks Off the Jersey Shore 113

10. A New Beginning of Station No. 119 119

About the New Jersey Maritime Museum 127

ACKNOWLEDGMENTS

Photographs are from the collections of the Tuckerton Historical Society (THS), with special thanks to John Yates for his expertise and patience; New Jersey Maritime Museum trustee George Hartnett (GH); Ron Marr, president of the Long Beach Island Historical Association (LBIHA); Jim Allen; Nancy and Oppie Speck (NRAS); CDR Timothy Dring, US Naval Reserve (Ret.) and Coast Guard historian (CDR Timothy Dring); author/historian Tom Farner (TF); and artist Cathleen Engelsen (CE), whose historical paintings are taken from her grandparents' photographs of the island. Many of the photographs came from the New Jersey Maritime Museum (NJMM) in Beach Haven, of which coauthor Deborah Whitcraft is founder and president. Coauthor Gretchen Coyle (GC) also provided images from her collection.

It is impossible to give credit to each photographer featured in this book, as so many of them are unidentified. Some of the photographs are duplicates; others were taken from different angles of the same subject; so many have been in the public domain for years. We appreciate the sharing, caring, and downright enthusiasm that has come our way as we created the first book ever written solely about Tucker's Island.

Shirley Burd Whealton's knowledge about Rider genealogy and her large family is priceless. Evelyn Cummings Suter was the last person alive to live on the island. Her childhood memories provided a unique perspective.

Records from the US Life-Saving Service and US Lighthouse Society/Bureau of Lighthouses have proved invaluable. The late John Bailey Lloyd wrote stories about Tucker's Island; his wife, Beach Haven historian Jeanette Lloyd who gives talks and portrays life on Tucker's Island. Both have been inspirations.

We would also like to thank acquisitions editor Katie Owens, who said yes over the phone, and Lily Watkins, our title manager and guide to writing Arcadia's first book about an island no longer in existence. We could not have put this book together without the expertise of Shannon Weaver Photography; she knows publishing and computers like no one else we have ever met.

Once again, our husbands, John Coyle and Jim Vogel, have encouraged us through another book. Their interest in New Jersey's illustrious maritime history never wanes; nor does ours.

INTRODUCTION

Tucker's Island was a New Jersey barrier island located on the Atlantic Ocean between Beach Haven and Little Egg Inlets. Due east of Tuckerton, "America's Third Port of Entry," Tucker's Island was once home to a Life-Saving station, lighthouse, schoolhouse/meetinghouse, two hotels, and a small community of summer cottages. It was positioned a few islands north of Atlantic City and directly south of Long Beach Island.

Since islands, though composed of trillions of grains of sand, tend to move, the exact location was hard to pinpoint at times. During 200 years of observation, Tucker's Island has been a barrier island; a peninsula joined with Long Beach Island; an island after a new inlet formed; and the second island in from the Atlantic behind Tucker's Beach.

Lenni-Lenape visited the island during the 1500s seeking fish and game. Henry Hudson sailed right by Tucker's Island in 1609. According to George B. Somerville in *The Lure of Long Beach*, "From the navigator's own diary, it appears that the *Half Moon* kept well within sight of land during the voyage from the Delaware Cape to Sandy Hook." In the 1600s, Dutch explorer Cornelius Mey found a sandy, marshy barrier island north of an inlet he had just named Little Egg Inlet after a plenitude of bird eggs.

Early explorers and surveyors named uninhabited islands after what they saw. Therefore, Tucker's Island was first called Short Beach. In the 1740s, farmer Ephraim Morse raised cattle on the island. Morse and his wife survived a winter storm that washed away their home and took the lives of their five children. Short Beach was sold, renamed Flat Beach, and passed on to Reuben Tucker in 1775.

Tucker built a house on higher ground, turning it into a tavern. In *Eighteen Miles of History*, John Bailey Lloyd writes the following about Reuben Tucker, who built a boardinghouse around 1800 on the island: "Such was his personality that his fame as a good host soon spread among watermen from Sandy Hook to the Carolinas." Tucker and his wife made their living hosting Quaker families from Philadelphia and Burlington County, New Jersey. Long, uncomfortable trips were made by a stagecoach through the rough Pine Barrens and then by sailboat to the island. Only the adventurous and hardy could appreciate what a sandy barrier island had to offer in addition to flies and mosquitoes. Tucker's venture was the first record of tourism along the Jersey Shore.

Cottages were built during the 1800s, and two hotels—the Columbia and the St. Albans—were constructed mainly with wood washed up from wrecks. There was no electricity or plumbing, but families who came to hunt, fish, and sea bathe had fun. Visitors of this era took the train to Tuckerton (Reuben Tucker's son Ebenezer named the town after himself) or Atlantic City, where horses and buggies transported them to nearby Leeds Point. The final leg was in a sailboat or steam yacht to the island. Flat Beach became the more sophisticated hotel Sea Haven. The St. Albans Improvement Company later sold lots, and the island also became known as St. Albans for a time.

Without a doubt, the Life-Saving station and lighthouse were the lifeblood of the island. Their combined efforts and dedication to helping others imperiled at sea were applauded near and far. Respect and hard work defined the Rider families and lifesavers who served on the desolate island for many years without the comforts of their mainland towns. Members of the Little Egg Life-Saving/Coast Guard Station and the Rider family of the Tucker's Island Lighthouse saved countless lives when ships were wrecked along their stretch of the "Graveyard of the Atlantic," as the Jersey coast is referred to. Ships were refloated, cargoes saved, and mariners nursed back to health.

In 1848, a small light was built to guide mariners into Little Egg Inlet. Criticism was quickly leveled against the unmanned, low-wattage light as ships' captains reported frequent groundings. A Henry LaPaute Fresnel lens order helped a bit, but the light was later deemed unnecessary and was extinguished in 1860.

After the Civil War, a new lighthouse, known as the Little Egg Harbor Light or Tucker's Island Light, was constructed. A center tower rose 50 feet above the lighthouse, which was inhabited by the first lightkeeper, Eber Rider Sr., and his family. Born on October 20, 1827, Rider developed a love of both the sea and service to his fellow man at an early age. Rider started as a young man with a big job and conducted himself as the ultimate professional, always clad in his black wool Life-Saving coat adorned with appropriate patch and pin.

The light now reached 12 miles at sea, overlapping the Barnegat Light 18 miles to the north and Absecon Light 10 miles to the south. The Rider family lived in a 20-by-30-foot, one-story house with detached kitchen. In 1879, the keeper's quarters were expanded to a spacious 11 rooms. Living a rather primitive lifestyle, with drinking water captured off the roof and stored in cisterns and growing and hunting what food they could, the Rider family members worked around the clock to keep the light lit for mariners along the coast. Cooking and heating required the use of kerosene and fireplaces. Ice was cut and stored from a pond on Tucker's Island.

Lighthouse keeper Eber Rider Sr. held his position for almost 40 years until his son Arthur Rider took over in 1904. This was an unprecedented record of longevity in the US Lighthouse Service. Eber Sr. was paid $550 annually for his service. His 1906 obituary in the *Tuckerton Times Beacon* pays tribute to the much-admired man, citing that he "had a record of honor with his government and fellow men." Shirley Burd Whealton writes in her Rider genealogy that his "faithfulness was rewarded by commendation from the Department at Washington as well as every other Lighthouse Inspector. He was notable in other aspects, as have been testified to by scores of others."

Mary Cranmer Rider, daughter of James and Martha Cranmer from Bass River, worked beside her husband, Eber. She experienced 20 pregnancies, raising children under conditions others would have thought intolerable. Bringing stranded sailors into her lighthouse home, Mary dressed their wounds and nursed them back to health until they could be transported to the mainland. Quietly, and with determined resolve, she was a leader on the small island. She died in the Tucker's Island Lighthouse under the care of her family.

Life-Saving station keeper Jarvis B. Rider, son of Eber Rider Sr., was born in Tuckerton in 1849. At the age of 20, he started as a volunteer at the US Life-Saving Service, taking over as keeper of the Little Egg Station (Coast Guard No. 119) in 1869 from Thomas W. Parker. Jarvis's first marriage to Rebecca Mott ended with her death on February 7, 1896. He then married Anna B. Darby in 1898. The family lived in a large home on Tucker's Island, built specifically for the US Life-Saving Service station keeper in 1879.

Located southwest of the lighthouse, the Life-Saving crew had to haul equipment to the beach to assist in rescues. At times, Harry, the horse, pulled the beach cart, which held the Lyle gun, breeches buoy, and other lifesaving equipment. Six men usually accompanied the station keeper, whose salary was $200 a year. Jarvis, like his father, had a distinguished career. He was the longest-paid keeper in the history of the US Life-Saving Service, working continuously for 46 years.

The *Toms River Courier* published the following letter from Jarvis Rider after his retirement in 1915:

> I served continuously as keeper for 46 years in one station. I have boated all kinds and sizes of wrecks, the value of vessels and cargos gotten off and assistance rendered by myself and my crew is $2,300,000. On account of shoals and flat beach I have always had to use my surfboat, except one schooner, the Nellie Treat, coal laden, which struck the beach just north of the lighthouse, with eight on board – very rough and dark. I could go and tell of a hundred dangerous trips and exposure endured in landing crews from the treacherous Little Egg Harbor Shoals. I have done my best and lost no man in my crew, nor a sailor that ever got in my surfboat.

Station keeper Jarvis Rider served as the first vice president of the National Surfman's Association, a position to which he was elected in 1910 at a convention in Providence, Rhode Island.

Evelyn Cummings Suter moved to Tucker's Island in 1913 with her mother and father, Ralph Cummings, who was a lifesaver. The family alternately lived on the houseboat *Independence* or in a bungalow. Once, they were evacuated from their houseboat to the Life-Saving station when the ocean met the bay. "My father tied the houseboat to the Life-Saving station so it wouldn't get away," The bungalow "was heated with kerosene. I had oilskins like my father," she delighted telling friends. "My father was an exceptional bayman."

Life on Tucker's Island was close to idyllic for a child, Evelyn reminisced: "There was a gramophone in the Life-Saving station where people could congregate and dance. Kids were put in the breeches buoy when the men drilled. Imagine going to school with only a few schoolmates." She remembered walking through quicksand where two horses had died in the late 1800s.

Evelyn Cummings Suter became a celebrity, speaking to groups about her life on Sea Haven, the island name she used. She adamantly corrected anyone who called the island Tucker's or any of its former names such as Short Beach, Flat Beach, or St. Albans's. Well into her eighties, she could capture an audience in the first few minutes. "Sea Haven was connected to Long Beach Island when I lived there, people can argue and I don't care, I lived there. I've never been happier than the time I spent at Sea Haven," Evelyn would say.

By the late 1800s, it was obvious that Tucker's Island was eroding at a fast rate. How could it be stopped in order to save the lighthouse, Life-Saving station, two hotels, a school, and homes? No one had a clue how to keep the sand in place.

As the inlet to the north widened, there was no doubt that the island would eventually disappear. Nature had taken over. The situation was man versus nature, with nature clearly winning. Certainly, Tucker's Island would not be the first island to disappear; nor would it be the last. In a day before pilings and strong foundations, buildings on barrier islands were constructed on foundations of cement, sand and shell, bog iron, or bricks. On Long Beach Island to the north, jetties designed by University of Pennsylvania engineer Lewis Haupt were set in place to help keep the beaches intact. However, this only hastened the wash of water across the northern end of Tucker's Island.

Arthur Rider took over as keeper of the Tucker's Island Light after his father died. From 1904 to 1927, he worked diligently in the family tradition while also fighting a disappearing island and government cuts. He wrote to the lighthouse inspector in Philadelphia protesting the deletion of the assistant keeper position, citing "all errands from this station must be done by boat. There are no men near the station (lighthouse) except those employed by the [US Life-Saving] Service." "Arth" was even more jovial than his father, posing for pictures surrounded by women and children. Keeper Arthur had three wives. He preferred life on the island, performing his lighthouse duties flawlessly and clamming, oystering, and crabbing in his off time for extra money.

As the years went by, weather had taken its toll on the Columbia and St. Alban's Hotels, both closed and beyond repair. But summer visitors came to their cottages, and day-trippers flocked to the island by boat. More erosion occurred with each storm, especially during the winter months. Letters to the inspector proved fruitless: "Nearly all of the foundation was washed from under the porch. Tucker's Beach Lighthouse is so much undermined that it has started to sag and lean toward the ocean." The building could no longer be used.

Sadly, Arthur Rider was relieved of his duties on September 30, 1927. An acetylene light was installed on a steel trestle as a temporary measure. Rider did not want to leave the island, so he decided to move the schoolhouse to higher ground for use as a residence. Paul Rider, great-nephew of Arthur Rider, was on Tucker's Island helping when they realized the lighthouse was about to fall. A final storm had left them stranded on the island, but it also left them in a position to capture the catastrophic events for posterity. Paul took photographs of the lighthouse falling with his Brownie box camera.

Paul Rider informed the *Tuckerton Times Beacon* that he "slept in the old lighthouse at Sea Haven, camera in hand, the night before she toppled. The government had officially abandoned

her some weeks before, and we knew she would go any minute. We went to the beach when the first crack appeared." A proud beacon for passing ships, the Tucker's Island Lighthouse fell into the Atlantic Ocean on October 12, 1927. In a few years, the Life-Saving station and schoolhouse met the same fate. Tucker's Island lay unused except for sporadic World War II use, and finally, the September 1944 hurricane completely inundated the island.

For over two hundred years, the ocean roared, storms battered the island, and erosion occurred. By 1950, the island was completely gone, leaving not a blade of grass or brick sticking up through the water. Two hundred years of illustrious history had disappeared.

Tucker's Island, also known as Short Beach, Flat Beach, Sea Haven, and St. Alban's, remains vibrant in New Jersey maritime history. It is a story of pioneers, brave baymen, strong women, unscrupulous real estate agents, and heroes who kept the beacon burning in the Tucker's Island Lighthouse and served with dignity in US Life-Saving Station No. 119.

One

LITTLE EGG HARBOR (TUCKER'S ISLAND) LIGHTHOUSE

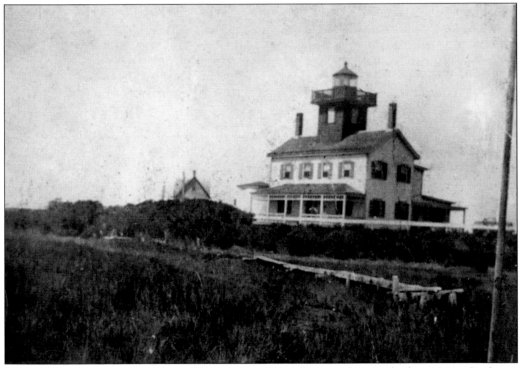

This is an early photograph of the Tucker's Island Lighthouse taken in the late 1800s. Bayberry and rugosa rose bushes grow in the front. To the left, partially hidden, is the oil house. The following details are given in a 1907 report by the US Department of Commerce and Labor Lighthouse Establishment: "Area of entire site—4 acres . . . Kind of stairway and steps—wooden . . . [water for essential living was] procured from the roof of the lighthouse by downspouts, into cisterns." (NJMM.)

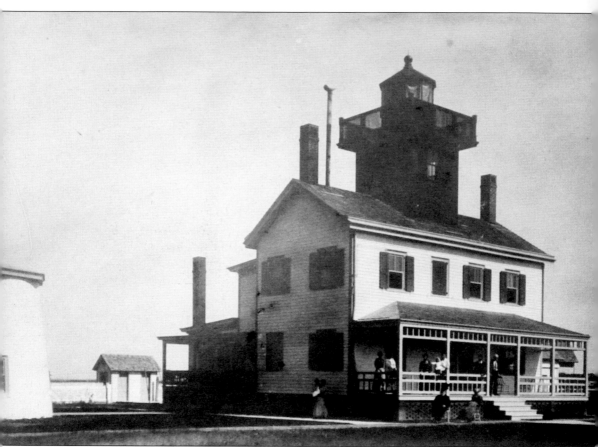

The lighthouse was a source of pride for the Rider family. Keepers Eber and Arthur Rider maintained the building in immaculate shape and were proud to show it off to visitors. This picture shows family and friends on the large front porch. They could come by sail or powerboat from Tuckerton on fair-weather days. Visitors in the late 1800s left from Edge Cove on the north side of Tuckerton on the *Barclay* or *Pohatcong*, two steam yachts that made their way to the fledgling town of Beach Haven. From the National Archives came reports of a boathouse being built, painted inside and out, and a frame extension built for a larger kitchen. In 1898, a telephone was installed, bedrooms added with shelves and a closet, and a new illuminating pedestal was added with a set of Funck-Heap lamps. The lighthouse was white with gray trim and green shutters; the lantern and tower were black. (THS.)

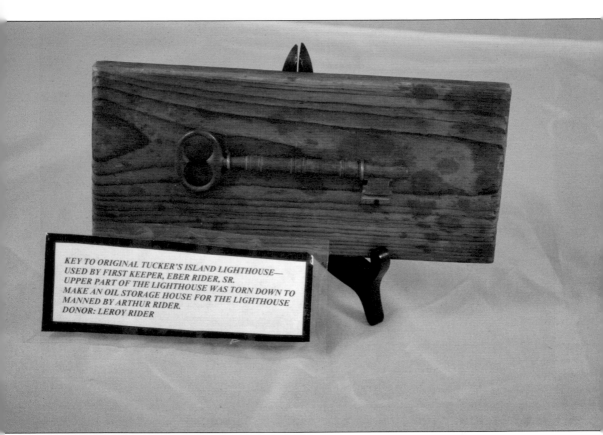

KEY TO ORIGINAL TUCKER'S ISLAND LIGHTHOUSE—
USED BY FIRST KEEPER, EBER RIDER, SR.
UPPER PART OF THE LIGHTHOUSE WAS TORN DOWN TO
MAKE AN OIL STORAGE HOUSE FOR THE LIGHTHOUSE
MANNED BY ARTHUR RIDER.
DONOR: LEROY RIDER

Leroy Rider Jr. donated the key to the original lighthouse to the Tuckerton Historical Society in 1986. The first lightkeeper, Eber Rider Sr., used it. The top part of this first lighthouse was torn down to make an oil house, which was used by the second keeper, Arthur Rider. With so many family members around, one wonders why a key was even necessary. The doors were probably locked at night to prevent intruders who could approach the lighthouse from the beach off a grounded ship or walk up from the US Life-Saving Service station. Arthur kept a rifle within easy reach, but no doubt the rifle was a show of force for protecting his family if necessary. It is now property of the New Jersey Maritime Museum, donated by Rider family member Shirley Burd Whealton. (THS.)

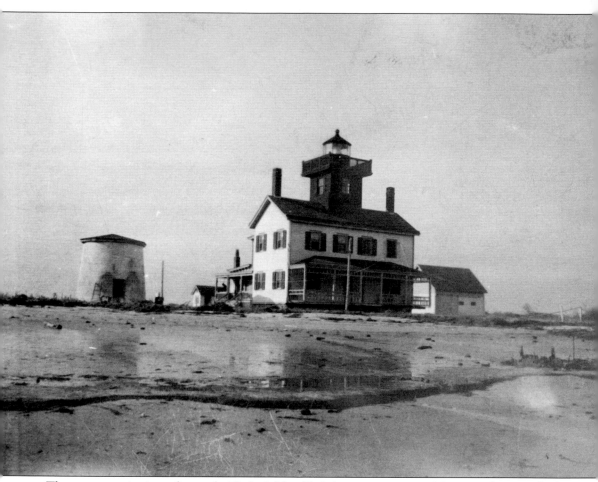

There was a majestic quality to the Tucker's Island lighthouse; it was one of the most photographed in New Jersey. This photograph was taken from the water along what used to be referred to as the slough. The slough was a shallow body of water, sometimes even filled with sand depending on the year. Hand-drawn charts from different years show Tucker's Island as a barrier island, a peninsula, and even an island behind a low-lying, narrow island, usually referred to as the beach. Evelyn Suter lived on Tucker's Island as a child while her father, Ralph Cummings, served in the US Life-Saving Service. She distinctly remembered people walking five or six miles south from Beach Haven to Tucker's Island for the day. A large beach to the east of the slough provided protection from the ocean. When the beach washed away, the lighthouse became more vulnerable. Taken on a calm day, this picture shows the best side of the lighthouse, but the water is closing in on the front porch. (NJMM.)

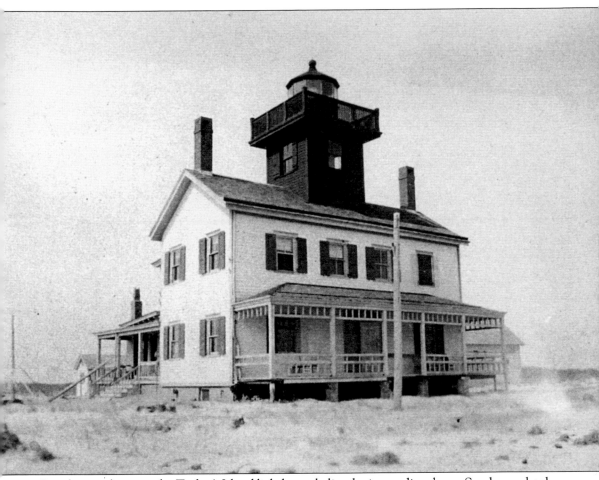

Sun shining down on the Tucker's Island lighthouse belies the impending doom. Sand completely surrounds the building. Left by an outgoing tide, clumps of seaweed are visible. Gone are all foliage, the walkway, and the small fence that outlined the lighthouse. The front steps have been washed away, as has the dark-green lattice that once covered the six brick footings, which held up the front porch. Shutters at the top-right window are shut, indicating a lighthouse all but deserted. The usual chairs and equipment that routinely graced the front porch have disappeared. While the tower seems intact, the light was last lit on September 9, 1927. Many people traveled from Tuckerton to witness the last lighting, some staying until the light was extinguished in the morning of the next day. It was a tribute to an important light that guided thousands of mariners for over a half century. (CE.)

Lighthouse keeper Eber Rider, followed by his son Arthur Rider, kept meticulous lighthouse journals. One is now part of the Tuckerton Historical Society collection of Tucker's Island artifacts, complete with a first page of specific instructions. Keepers were to "include a complete record of important events, work in progress, officials visiting the station, visibility of adjacent lights and gas buoys, weather conditions, absences of light keepers, and any irregularities in working of equipment or appliances at the station." The journal was to be printed in ink and updated daily, listing the time of illuminating and extinguishing the light. Specifics include the following: "Postponement of entries will not be permitted . . . [and] no entries in this book shall be erased." Inspectors came regularly, many times purposely without notice. "This journal shall be presented for examination at each inspection of the station and signed by the inspecting officer with such comments as he deems desirable." Lighthouse keepers were expected to write down all shore liberties or annual leaves. (THS.)

FORM 188
DEPARTMENT OF COMMERCE
LIGHTHOUSE SERVICE

1925 MONTH	DAY	STATE WORK PERFORMED BY KEEPERS REGARDING UPKEEP OF STATION, AND RECORD OF IMPORTANT EVENTS, WEATHER CONDITIONS, ETC.
January	11	Cloudy and snow most of day with fresh Northeast wind. Barnegat and Absecon lights not seen much
	12	Cloudy and fine rain with strong Northeast and Easterly winds. S.H. light out Barnegat and Absecon lights not seen; rain and mist
	13	Keeper 59 years old today. Cloudy, cloudy with moderate Southeast wind. Barnegat & Absecon lights not seen, cloudy. Sea Haven light out and relighted
	14	Clear with moderate westerly winds most of day. Barnegat and Absecon lights not seen clear overhead S.H. light out
	15	Clear with very light variable wind and calm. Sea Haven light out and relighted. Barnegat and Absecon lights not seen clear overhead
	16	Cloudy and light rain with very light Easterly winds, becoming fresh in evening. Barnegat and Absecon lights not seen, fog & mist
	17	Cloudy with light variable winds calm most of night. Sea Haven light out. Barnegat and Absecon lights not seen, misty
	18	Cloudy with moderate Northeast wind, calm in afternoon. New burner and pilot put on Sea Haven lamp. Barnegat and Absecon lights not seen, cloudy
	19	Sea Haven light burned all last night. Cloudy with moderate Northeasterly winds becoming fresh and strong during night. Barnegat and Absecon lights not seen, cloudy & rain
	20	Rain with heavy Northeast changing to East, South, West and Northwest winds. Barnegat and Absecon lights not seen. Clearing. Sea Haven light out - probably for want of gas
January	21	Clear with moderate westerly wind. Sea Haven light out - will not remain lighted. Barnegat and Absecon lights not seen, clear
	22	Clear with moderate Southwest and west wind. Barnegat and Absecon lights not seen, clear
	23	Clear with strong Northwest wind becoming moderate during night. Barnegat and Absecon lights seen, clear
	24	Clear with moderate North, East and Southerly winds. S.H. light will not burn. Barnegat and Absecon lights seen, clear
	25	Cloudy and partly cloudy. Moderate Southerly winds. S.H. light will not burn. Barnegat and Absecon lights not seen, cloudy
	26	Cloudy with light variable wind. Barnegat and Absecon lights not seen, cloudy
	27	Cloudy and light snow with strong Northerly winds. Barnegat and Absecon lights not seen, snow
	28	Snow with strong Northerly winds becoming moderate at night. Barnegat and Absecon lights not seen, clear
	29	Cloudy with fresh East and strong East wind with rain. Barnegat and Absecon lights not seen, clearing
	30	Clear with fresh Westerly winds. Barnegat and Absecon lights not seen, clear
	31	Clear with moderate west and South winds. Barnegat and Absecon lights seen, clear
February	1	Cloudy with very light variable winds. Barnegat and Absecon lights not seen, cloudy

Keeper Arthur Rider always recorded his logbook entries as A.J.H. Rider and his location as Tucker's Beach. His log entries are all dated and well written, always starting with the weather. On January 11, 1925, he wrote: "Cloudy and snow most of the night. Barnegat and Absecon lights not seen much." The idea of the US Life-Saving Service was that lights should be placed approximately 20 miles apart so that their beacons would overlap. This was based on the premise of clear weather. On January 20, 1925, the tone was different, noting "rain with heavy northeast (winds) changing to East. Sea Haven light out." It is easy to imagine the Rider family hustling to fix whatever was wrong with the light. Lighthouse tending was a family affair; normally, children carried buckets of oil up the steps to refill the light daily, in addition to other chores. As was common, the February 1, 1925, entry reads, "Cloudy with very light variable winds. Barnegat and Absecon not seen." (THS.)

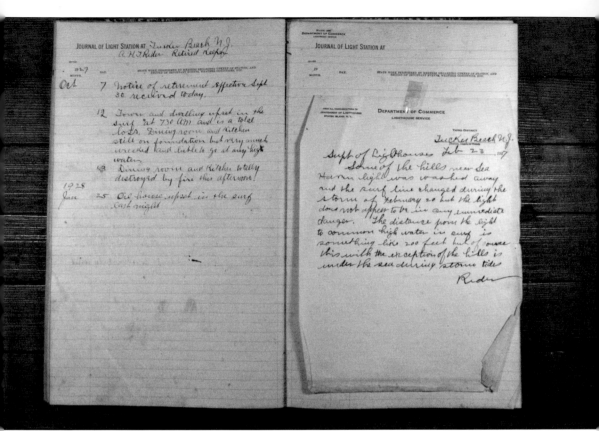

It is eerie and sad to read the last Tucker's Beach log entry ever made by Arthur Rider. Was he disgusted or hurt when he wrote on October 7, 1927: "Notice of retirement effective September 30th received today." An artifact at the Tuckerton Historical Society, the last journal of log entries tells of the end being only days away. His entry dated October 12 tells of the "tower and dwelling upset in the surf at 7:30am." On October 13, he wrote, "Dining room and kitchen totally destroyed by fire this afternoon." The following is the last log entry, recorded on January 25, 1928: "Old house upset in the surf last night." On the far page of the last log entry is taped a letter, provided by Win Salmons and Pep Salmons. Dated February 23, 1927, it is another desperate letter from Arthur Rider to the US Lighthouse Service, which reads, "Some of the hills near Sea Haven Light were washed away and the surfline changed during the storm of Feb. 20th." (THS.)

DEPARTMENT OF COMMERCE

LIGHTHOUSE SERVICE

THIRD DISTRICT

Tuckers Beach N.J.
(Station, Depth, or Vessel)

Feb 21 _____, 1927

Supt. of Lighthouses

During the storm yesterday from 7:30 to 11:30 AM the whole reservation this station was badly swept by the sea from the ocean.

Nearly all the foundation was washed from the front porch as well as about 24 feet of the sill. The porch steps and part of the railing was also washed away. The porch did not go down but is started from the building. The hand rails was washed away from the back porch steps and one of the barn doors was damaged. The lot on the seaside is badly cut by the sea and nearly all the fence is ruined and washed away. Some of the sea water got in both cisterns. All of Long Beach that was in front and several hundred yards on either side of this station has washed

away and the station has no protection from the surf, and is unsafe for occupancy during a storm.

It is quite evident that the station will be lost in the surf unless protected.

I suggest that someone from the office come for inspection.

I might add that the old hotel that stood about 200 feet away and another house about 500 feet away was washed down and totally destroyed yesterday.

Rider

Keeper Arthur Rider attempted to keep his Lighthouse Service superiors informed of the devastation that kept occurring on Tucker's Island. "During the storm of yesterday (Feb. 20, 1927) from 7:30–11:30am, the whole reservation at this station was badly swept from the sea by the ocean. Nearly all the foundation was washed from the front porch, as well as about 24' of the sill," keeper Rider wrote to the superintendent of lighthouses. Sounding at his wit's end, he hoped for an answer, but no answers or solutions were given to him. His lifetime of experience with erosion had left him concluding the worst. "The porch steps and part of the railing was also washed away. The porch did not go down but started from the building. The hand rails washed away from the back." He closes his letter with almost a plea, "I suggest someone from the office come for inspection. I might add that the old hotel that stood about 200' away and another house about 500' away was washed down and totally destroyed yesterday." (THS.)

DEPARTMENT OF COMMERCE

LIGHTHOUSE SERVICE

THIRD DISTRICT

Tucker Beach N.J
(Station, Depot, or Vessel)

July 12, 1927

Supt of Lighthouses

During the last few days
especially July 2nd and 3rd the surf
has washed away some more off
the front of the reservation.
The surf did not go across the
lot but undermined and broke it
down. The distance from the front
porch to the break down and from
23 to 25 feet. About 29 feet
of the concrete walk that lead to
the front gate is undermined
and broke down.

Rider

It is easy to read the frustration and defeat in keeper Arthur Rider's July 12, 1927, letter to the superintendent of lighthouses on Staten Island, New York. "During the last few days especially July 2nd and 3rd, the surf has washed away more of the front of the reservation. The distance from the front porch to the breakdown is from 23–25," he informs his superiors. Rider sounds weary, a man tired of fighting the inevitable outcome of his lifetime dedication to the Tucker's Island Light. He is not writing a formal or friendly letter here but bluntly stating the facts and waiting for guidance and instructions. None are forthcoming at this point. He gives his location as Tucker's Beach and begins his salutation with just "Supt. of Lighthouses." He goes on to write that "about 29' of the concrete walk that lead to the front gate is undermined and broken down." Even a small sand dune erected to keep the ocean away has failed; there are no more ways to defend the lighthouse. Keeper Rider's letter does not have a complimentary closing; he simply signs his last name. (THS.)

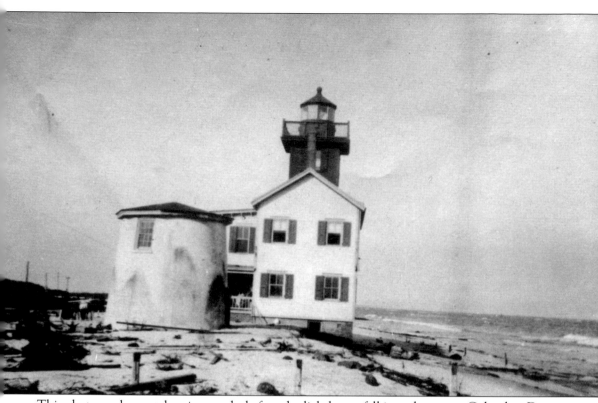

This photograph was taken just weeks before the lighthouse fell into the sea on Columbus Day, October 12, 1927. On February 4, 1920, a howling nor'easter hit the New Jersey coast. A new inlet opened up at the town of Holgate, located just below Beach Haven. The flow of rushing water hastened the erosion of Tucker's Island. Water lapped closer and closer to the lighthouse, with sand disappearing at a fast rate. On August 26, 1927, another storm battered the lighthouse. Water flowed freely under the foundation, and the front porch fell off. Within a few weeks, the building began to tilt; the interior was cracking. Charles Edgar Nash writes in the *Sea Breeze* about the efforts Arthur Rider had made; he states, "The captain has filled forty burlap bags with sand and placed them at strategic points around the brick walls to break the force in the constant pounding of the hungry waves. We would advise a trip to Tucker's Beach, for it will take a miracle to save the husk of the old beacon." (NJMM.)

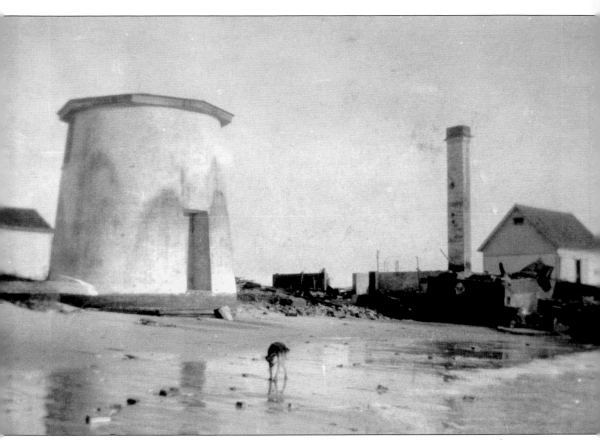

The original 52-foot Tucker's Island Light was a tower. A January 1839 petition by "masters and owners of vessels in the habit of using the new inlet at Little Egg Harbor" was aimed at New Jersey legislators. An 1846 act dictates that a light will be built to aid mariners if money is appropriated: "Be it resolved by the Senate and General Assembly of the State of New Jersey, that our senators and representatives in congress be requested to use their influence to obtain a sufficient appropriation for the purpose of constructing a light-house." Federal government money was obtained, and the light was constructed in 1848. Red flashes warned mariners off the shoals. The light functioned until 1859, when it was turned off. When the lighthouse was constructed, the bottom part of the original light was used as an oil shed and storage area. The first lightkeeper, Eber Rider, made good use of this brick building next to the wooden lighthouse. After the seas toppled the lighthouse, the oil shed was left standing. However, in a few years it, too, was undermined and fell. (THS.)

Two

LIGHTKEEPERS EBER RIDER AND ARTHUR RIDER

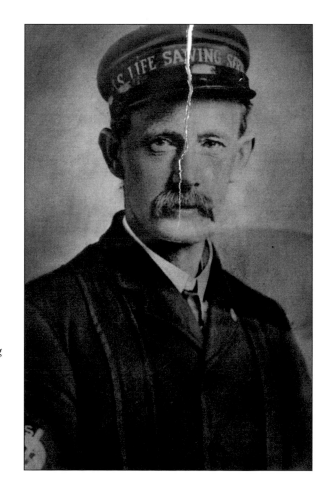

This may be the oldest photograph of keeper Eber Rider Sr. in existence. He is shown here as a relatively young man in his official US Life-Saving hat and jacket. Being a lightkeeper was not only an honorable position but also a hard one. He lugged 243 gallons of kerosene a year in buckets from the oil house to the lighthouse and kept the light working. Rider never let the light go out. (THS.)

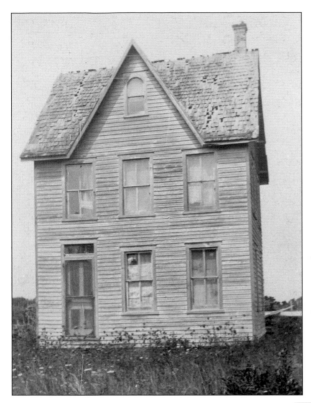

Here, many shingles have blown off the roof of "Pappy" Eber Rider's old home. This image symbolizes the end of Tucker's Island. It was deserted and washing away, and a small community of hardworking families was forced to retreat to the mainland. Tucker's Island was removed from Long Beach Township tax records on November 8, 1932. The last building to be washed away was Arthur Rider's schoolhouse-turned-home on the island's highest ground. (THS.)

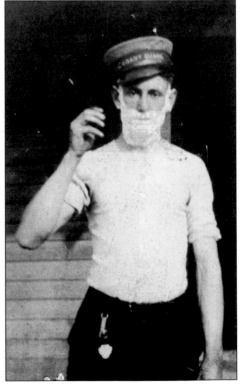

Life on Tucker's Island had its light moments. Here, Eber Rider Jr., who was a surfman at the Little Egg Station on the southwest side of the island, is pictured with shaving cream on his face and a straight razor in hand. Working together, members of the US Life-Saving Service and Lighthouse Service keepers have assisted hundreds of mariners over the years. (THS.)

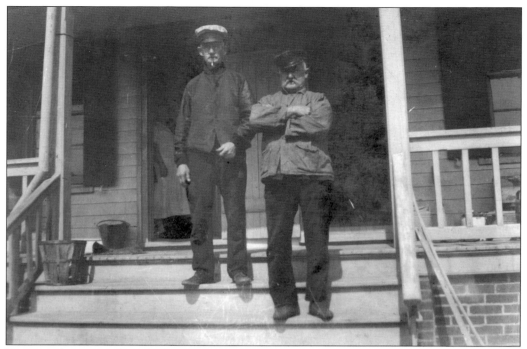

Two proud men stand on the back steps of the Tucker's Beach Light, as it is referred to in official log journals. Keeper Eber Rider (left) is taller than his son Arthur, who followed in his father's footsteps; both men emanate an air of authority and competency. (THS.)

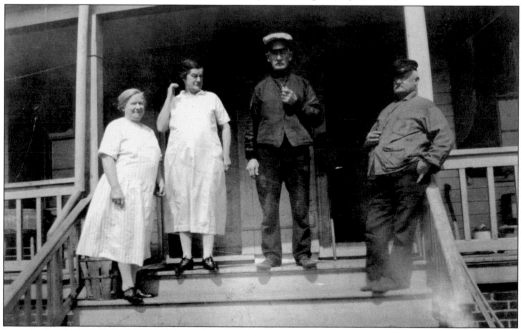

Patriarch Eber Rider Sr. poses for a family photograph with his son Arthur Rider and his wife, Nellie. At center is Rose Ireland Rider, second wife of Eber Jr. No photographs of Eber's wife, Mary Rider, have been found. There was a very strong bond between father and son. Both distinguished lightkeepers, they also shared a propensity for pipe smoking. (THS.)

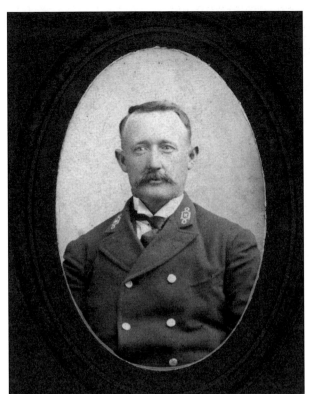

Born on January 13, 1866, Arthur Rider first went to Tucker's Island at the age of four months. Captain "Arth," as everyone called him, started helping his father, Eber Rider Sr., in May 1877. He then took over his father's position on January 1, 1904, with the official title of keeper of the lighthouse. Arthur was the consummate professional, as seen in this photograph. (THS.)

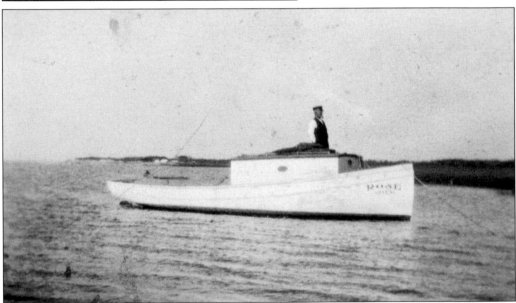

This photograph shows Arthur Rider fishing in the family's boat *Rose* (named after Rose Jones Ireland Rider). Keeper Arthur preferred his life on the island to that in Tuckerton. His friends were members of the extended Rider family and those stationed at the Life-Saving station. Arthur had three different wives—Melinda Andrews, whom he married in 1898; Nellie Falkinburg, whom he married in 1915; and former schoolteacher Florence Morse, whom he married in 1935. (LBIHA.)

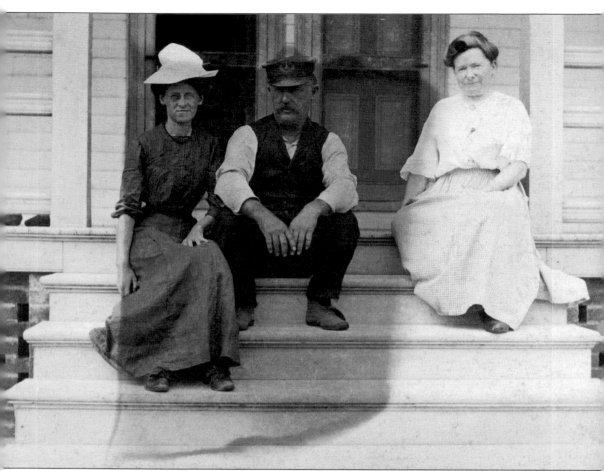

Keeper Arthur Rider relaxes on the front porch steps of the lighthouse with his wife, Nellie Falkinburg Rider (left), and Rose Ireland Rider. Serving others in the US Life-Saving Service/ Coast Guard was a Rider tradition, an honorable one that not only guaranteed a paycheck but also a lifetime of strenuous and dangerous work. Most of the men in the Rider family preferred work that kept them outdoors much of the time. Arthur is often photographed standing or sitting on the steps; no doubt, it was a good place to view ships passing by and to check for any wrecks on the horizon. Over many long years, Arthur had only journeyed to Niagara Falls, Baltimore, Washington, and New York. Rose and Nellie are dressed in their daily clothes of long skirts and elbow-length sleeves. Nellie looks a bit warm in her dark dress, but she is sensibly wearing a hat to keep the sun off her head. (THS.)

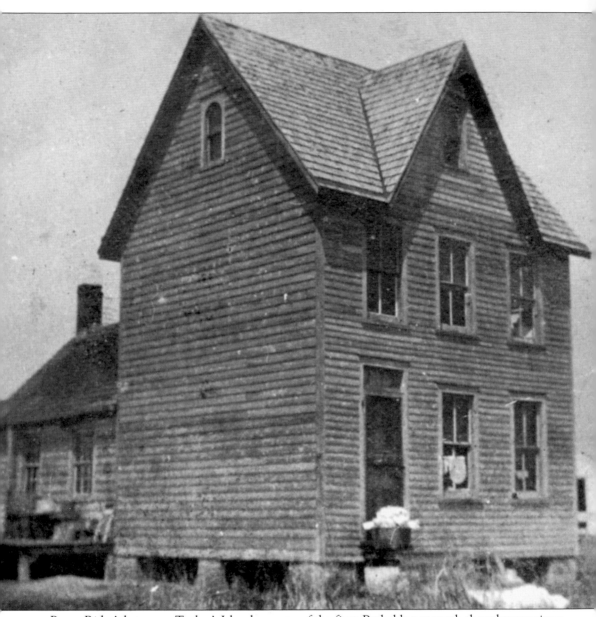

Pappy Rider's house on Tucker's Island was one of the first. Probably not much thought was given to the building's looks. Houses on Tucker's were strictly functional. They were cold in winter with only potbellied stoves or small fireplaces, and they were hard to keep cool in summer in spite of sea breezes. Homes were somewhat easy to construct. Small brick footings were placed in the sand, which was later a problem when water washed around them, causing structures to fall. As many building materials as possible were collected off the beach; for example, wood—from cargo swept overboard from passing ships during bad weather, thrown off a grounded ship that needed to lighten its load, or from a ship that had wrecked—washed up on a regular basis. It was expensive and time-consuming to have materials barged from mainland ports. Screens are not visible in many of the homes; they simply blew out during the howling winter months. As for those cute little buildings behind each house, they were outhouses. Plumbing and electricity were commodities of the future. (THS.)

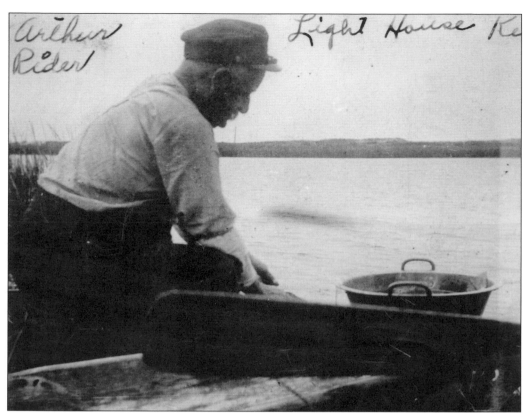

When not tending to his lighthouse duties, keeper Arthur Rider could often be found in his small boat, clamming. The strenuous work of manning a lighthouse and living on a barrier island all took its toll. The final blow to his career was when he was "retired" or dismissed. He is quoted as saying to family members, "I just got this letter now. It's about my pay. They retired me on September 30th." (LBIHA.)

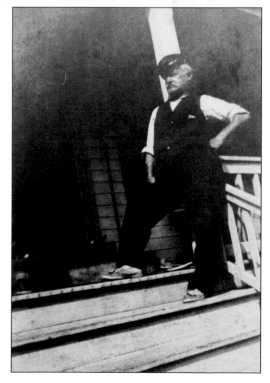

As Arthur Rider aged, he put on weight and had a stoop in his walk. While he still sports a mustache, the physical demands show the effects of living on an island and tending a lighthouse. To make extra money, the family sold clams and other seafood. They transported the seafood to the railroad in Beach Haven. From there, it was exported to Philadelphia and New York. (THS.)

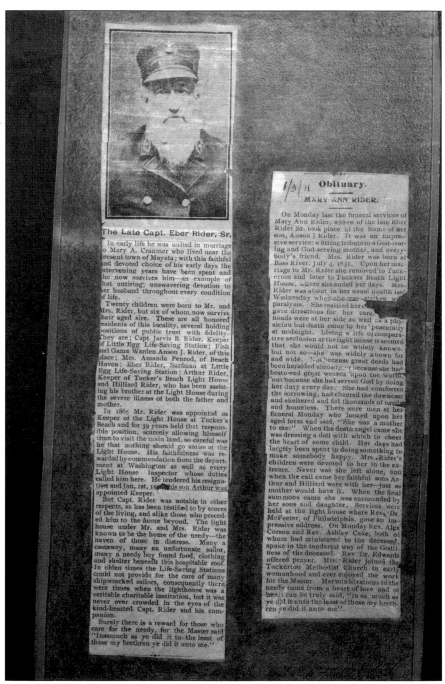

The Late Capt. Eber Rider, Sr.

In early life he was united in marriage to Mary A. Cranmer who lived near the present town of Mayeta; with this faithful and devoted choice of his early days the intervening years have been spent and he now survives him—an example of that untiring, unswerving devotion to her husband throughout every condition of life.

Twenty children were born to Mr. and Mrs. Rider, but six of whom now survive their aged sire. These are all honored residents of this locality, several holding positions of public trust with fidelity. They are; Capt. Jarvis B. Rider, Keeper of Little Egg Life-Saving Station; Fish and Game Warden Anson J. Rider, of this place; Mrs. Amanda Penrod, of Beach Haven; Eber Rider, Surfman at Little Egg Life-Saving Station; Arthur Rider, Keeper of Tucker's Beach Light House and Hilliard Rider, who has been assisting his brother at the Light House during the severe illness of both the father and mother.

In 1865 Mr. Rider was appointed as Keeper of the Light House at Tucker's Beach and for 39 years held that responsible position, scarcely allowing himself time to visit the main land, so careful was he that nothing should go amiss at the Light House. His faithfulness was rewarded by commendation from the department at Washington as well as every Light House Inspector whose duties called him here. He tendered his resignation and Jan. 1st, 19.. his son Arthur was appointed Keeper.

But Capt. Rider was notable in other respects, as has been testified to by scores of the living, and alike those who preceded him to the home beyond. The light house under Mr. and Mrs. Rider was known to be the home of the needy—the haven of those in distress. Many a castaway, many an unfortunate sailor, many a needy boy found food, clothing and shelter beneath this hospitable roof. In olden times the Life-Saving Stations could not provide for the care of many shipwrecked sailors, consequently there were times when the lighthouse was a veritable charitable institution, but it was never over crowded in the eyes of the kind-hearted Capt. Rider and his companion.

Surely there is a reward for those who care for the needy, for the Master said "Inasmuch as ye did it to the least of these my brethren ye did it unto me."

Obituary.
MARY ANN RIDER.

1/3/11

On Monday last the funeral services of Mary Ann Rider, widow of the late Eber Rider Sr. took place at the home of her son, Anson J Rider. It was an impressive service: a fitting tribute to a God-fearing and God-serving mother, and everybody's friend. Mrs. Rider was born at Bass River. July 4, 1831. Upon her marriage to Mr. Rider she removed to Tuckerton and later to Tuckers Beach Light House, where she ended her days. Mrs. Rider was about in her usual health last Wednesday when she was stricken with paralysis. She realized her c... gave directions for her care. ... hands were at her side as well as a physician but death came to her peacefully at midnight. Living a life of comparative seclusion at the light house it seemed that she would not be widely known. but not so—she was widely known far and wide. Not because great deeds had been heralded abroad, or because she had bestowed great wealth upon the world, but because she had served God by doing her duty every day. She had comforted the sorrowing, had cheered the downcast and sheltered and fed thousands of needy and homeless. There were men at her funeral Monday who looked upon her aged form and said, "She was a mother to me." When the death angel came she was dressing a doll with which to cheer the heart of some child. Her days had largely been spent in doing something to make somebody happy. Mrs. Rider's children were devoted to her in the extreme. Never was she left alone, and when the call came her faithful sons Arthur and Hilliard were with her—just as mother would have it. When the final summons came she was surrounded by her sons and daughter. Services were held at the light house where Rev. Dr. McFeeter, of Philadelphia, gave an impressive address. On Monday Rev. Alex Corson and Rev. Ashley Cake, both of whom had ministered to the deceased, spoke in the tenderest way of the Godliness of the deceased. Rev. Dr. Edwards offered prayer. Mrs. Rider joined the Tuckerton Methodist Church in early womanhood and ever enjoyed the work for the Master. Her ministrations to the needy came from a heart of love and of... it can be truly said, "in as much as ye did it unto the least of these my brethren ye did it unto me".

A photograph of lightkeeper Eber Rider Sr. accompanies his long and detailed obituary. Well respected, he was known far and wide for his efforts on behalf of rescuing stranded mariners. "Twenty children were born to Mr. and Mrs. Rider, but six of whom now survive their aged sire. These are honorable residents of this locality." The much-loved widow of Eber Rider Sr., Mary Cranmer Rider, passed away in the lighthouse then cared for by her son Arthur and the family. "There were men at her funeral who looked upon her aged form and said, 'She was a mother to me.' Mrs. Rider's children were devoted to her in the extreme." (THS.)

Three

THE COLUMBIA AND ST. ALBANS HOTELS AT SEA HAVEN

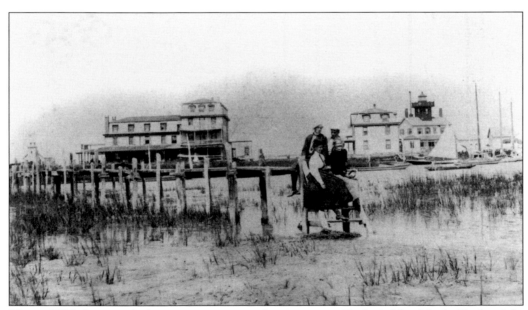

This c. 1885 photograph shows two young couples sitting on a Tucker's Island dock. To the right are the Columbia Hotel and lighthouse. The masts of four sailboats can be seen. This is one of the earliest photographs of St. Albans Hotel in existence. Keeper Eber Rider built the St. Albans Hotel during the summer months of 1879. It started out as a huge success. (THS.)

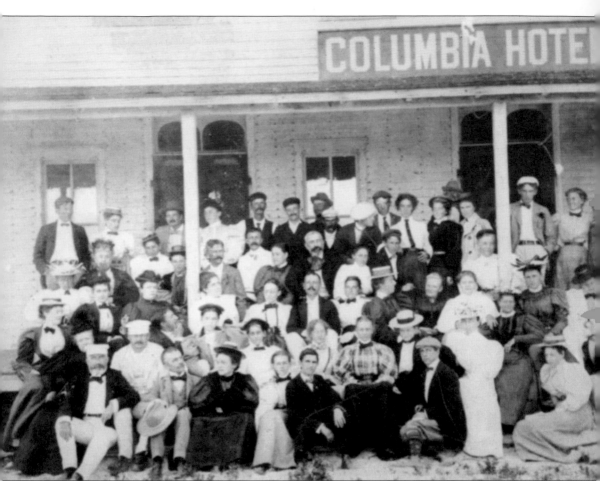

Who cared about flies and mosquitoes, or a lack of plumbing and electricity, when fun could be had at the Columbia Hotel? Around the year 1900, over 50 guests gather around on the steps. The ladies are adorned in long dresses with puffy sleeves and hats, and the men are in coats and ties. Away from industrial cities full of smog, they spent hours on ferries, trains, and boats to reach Tucker's for this vacation. The St. Albans Hotel had purposely been built directly in front of the slough; visitors walked down the hotel steps directly onto sand and dune grass. The hotel hardly had a vacancy during its first 20 years. Families flocked to the St. Albans; a vacation on a real island surrounded by water held great appeal. Baymen acted as hunting and fishing guides. Fresh seafood and game were served at every meal. Singing and drinking were nighttime pastimes. (THS.)

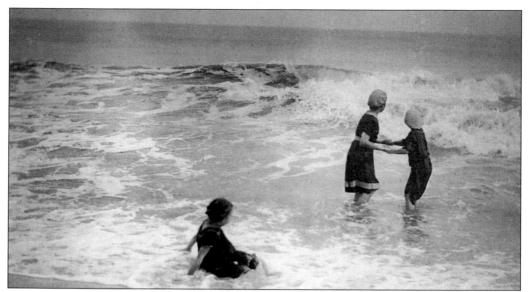

Three young children frolic in the Atlantic Ocean on a calm summer day. Dr. Jonathan Pitney of Atlantic City was considered to have coined the phrase "sea bathing." A physician who stressed outdoor activities as a way to ward off illnesses, he encouraged visitors to enjoy the water. The popularity of sea bathing quickly spread to places like Tucker's Island. Note the children's bathing costumes; they look much like rompers. (THS.)

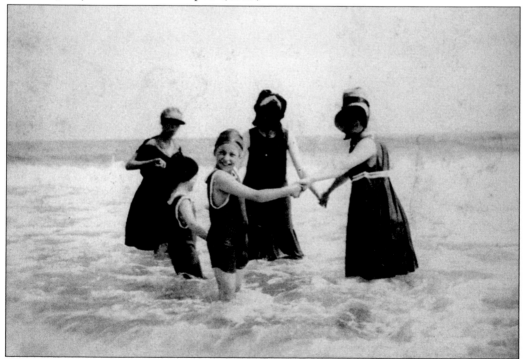

Pictured are mothers and children in the water. Children here wear long wool tank suits with white-trimmed armholes for flexibility when ducking under waves. Bathing caps hold their hair in place. Mothers still aim for modesty in loose bathing costumes that fall below their knees. Full-brimmed hats protect their faces from the sun. (THS.)

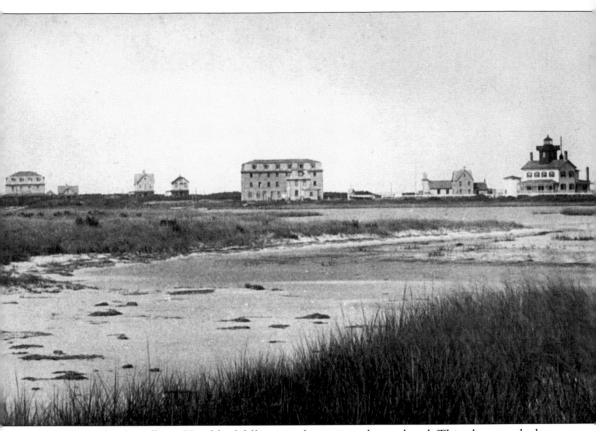

By 1910, the St. Albans Hotel had fallen into disrepair and was closed. This photograph shows windows blown out by storms and a building weathered by the elements. Advertisers for the Tucker's Island hotels had once—blatantly and perhaps deceivingly—advertised that "there are no land breezes, mosquitoes, malaria or fogs, and the pure saline atmosphere is certain relief from hay fever and kindred ailments." However, a US Signal Service station was erected to give businessmen contact with their offices. "Hotel accommodations are unsurpassed. Several fine cottages are now being built, and choice lots are offered to early buyers at extremely low prices and reasonable terms." Tucker's Island was losing its popularity. It was easier and less time consuming to get to either Atlantic City or the successful town of Beach Haven because both had easy railroad access; they also had modern hotels and stores. (CE.)

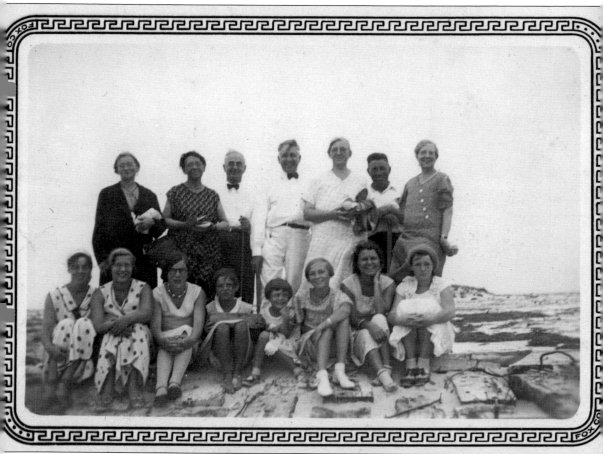

New Jersey Maritime Museum trustee (and Arcadia author) George Hartnett, of Moorestown, New Jersey, supplied photographs from a Nichterlein family album. In this image taken in the 1920s, family and friends are sitting on the wreckage of one of the buildings, probably the St. Albans, which was the closest to the ocean. The devastation and continual erosion do not seem to deter this happy group. People are labeled on the back of the photograph as follows: "First row, left to right: Edna Parker, Margaret Schmittheimmer, me, Lois, Marie Smith, Frances Smith, Abby Atkinson, Barbara. Second row left to right: Mrs. Hartmeir, Mr. Schmittheimmer, Mother, Dad, Mrs. Schmittheimmer." Some names are unaccounted for in the back row. Men are sporting bow ties, while the ladies and children are in casual dresses. (GH.)

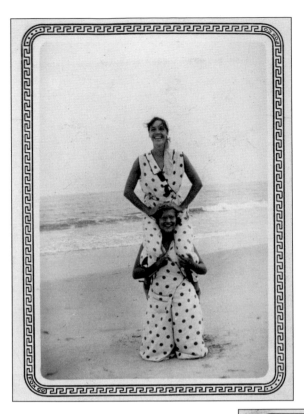

Blonde-haired Margaret Schmittheimmer is on her knees in the sand holding dark-haired Edna Parker on her shoulders. The girls are dressed in identical white pants and matching blouses with large polka dots. The photograph is marked "Surprise Birthday." (GH.)

This photograph from the Nichterlein family album is only marked "Surprise Birthday Party at Sea Haven." The young lady in this photograph is extremely well dressed in a 1920s daytime look. As befitted the times, people still wore appropriate, modest clothing at the beach though outfits could become soiled and shoes could sink into the sand. (GH.)

Four

LIFE ON TUCKER'S ISLAND

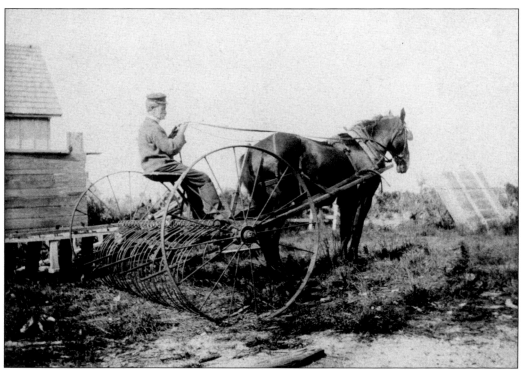

Warner Rider of the US Life-Saving station owned the horse Harry. Harry was used on Tucker's Island for about 10 years. He was used to pull the equipment across the sand to aid stranded mariners and by several of the Rider family members to move building materials and perform other labors needed on the island. In this picture, Jarvis Rider, station keeper, commands Harry's strength to harvest salt hay. (CE.)

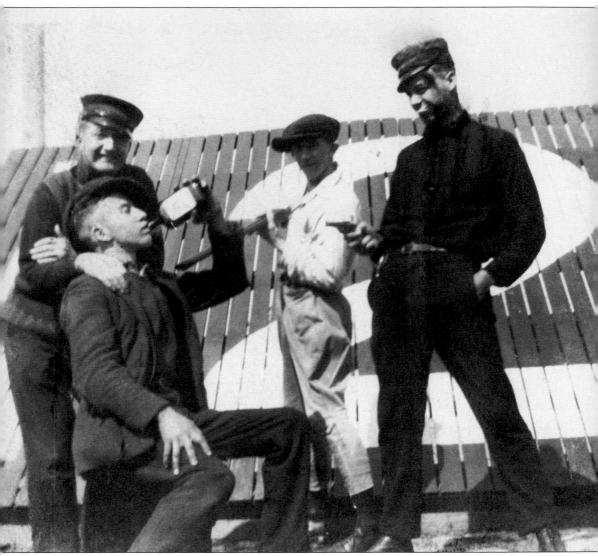

Prohibition is still debated, even 80 years after it was repealed. As everywhere else, those living on Tucker's Island had opposing views. In this photograph, men at Station No. 120 express their preference for good booze. One takes a long drink while his smiling buddy waits his turn. Holding a shotgun and a small pistol, two other Coast Guardsmen fake an arrest. Both are smiling, wondering when they will get their swigs. The Coast Guard was under federal orders to arrest those breaking the rules of Prohibition—that is, to apprehend all boats bringing liquor into the country. Most rumrunners were local boat captains trying to make money. Unfortunately, the Coast Guard was sworn to arrest the rumrunners who were, in many cases, their friends. This posed photograph expresses exactly what the men on Tucker's Island, possibly drinking confiscated alcohol, felt about Prohibition. (NJMM.)

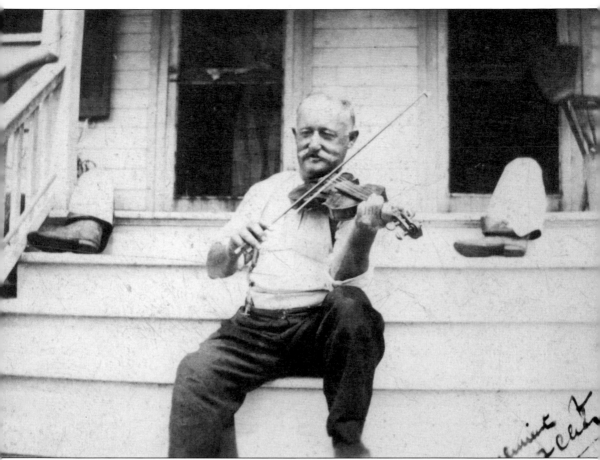

Life on a small island could be horrendous for some people. Summers were hot and buggy, while in winter, the storms did not stop coming and the wind howled. Inadequate structures could not be kept warm. Inhabitants had to entertain themselves in whatever ways they could. In addition to working the lighthouse and fishing and clamming, keeper Arthur Rider found contentment playing a violin he referred to as his fiddle. The self-taught Rider could pick up music he had heard and play it. Here, a lady is shown in the background behind the screen door. High waders are drying out on the top step and a broom is doing the same in this 1919 photograph. (NJMM.)

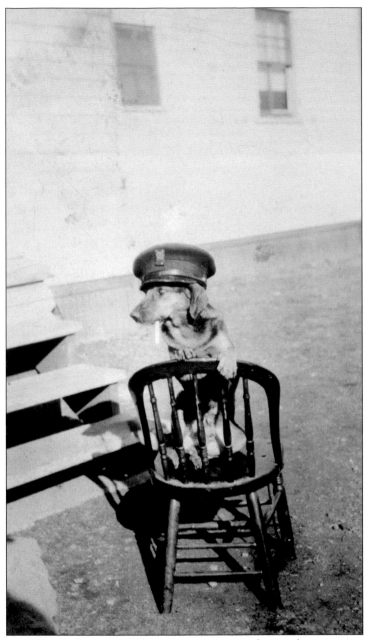

A dog pleases its unidentified masters at the Life-Saving station by standing on a government-issued bentwood chair with a Coast Guard hat on. The date has to be after 1915, when the Coast Guard was formed following the merger of the US Life-Saving Service and Revenue Cutter Service and the uniforms were changed. This pleasing pup is wearing the newer Coast Guard cap. There are no records of dogs on Tucker's Island, but they appear in a number of photographs. What better place for dogs to spend their lives than wandering the island, finding warmth and friendship from the Coast Guard members and getting handouts from dinners made of fresh fish and small game? Dogs were commonplace at Coast Guard stations: Sinbad, a "retired" World War II canine veteran, spent his last days at Station Barnegat, Long Beach Island's northernmost station. (THS.)

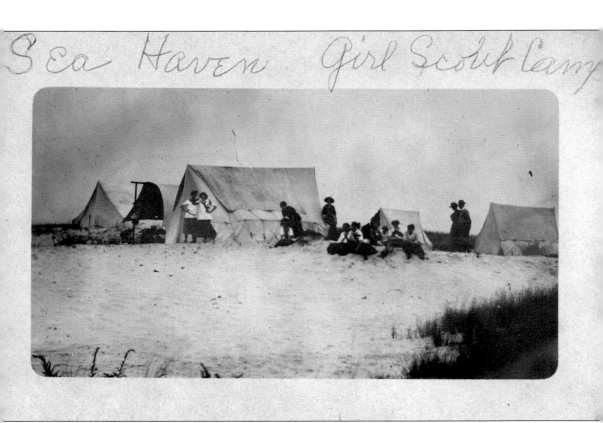

Here, young Girl Scouts in their uniforms of long, dark skirts and middy blouses with ties pose for this early-1900s photograph. Heavy canvas tents were erected in the sand dunes to keep everyone from getting wet. Sleeping tents have canvas overhangs, while the dining tent (second tent from left) is open. Chaperones stand behind the young ladies in dark clothes and hats. Margaret "Pep" Jones's name is attached to this photograph, though whether she was a Girl Scout, a mother, or a chaperone is unknown. The Jones family of Tuckerton owned the cottage Skeeters and spent a lot of time on Tucker's Island. (THS.)

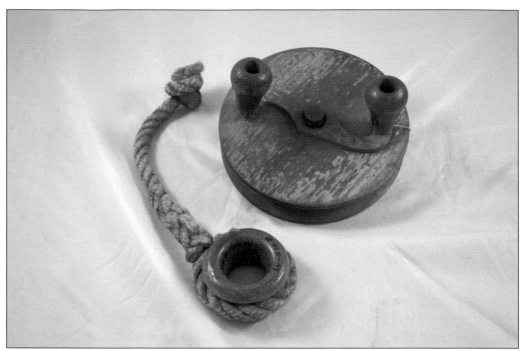

The Tuckerton Historical Society has a collection of Tucker's Island memorabilia donated by Leroy Rider Jr. This wooden fishing reel was used in the late 1800s. It is not known for what purpose the short Manila line with eye splice around a wooden grommet was used. Fishing was not only essential for survival, but also a fun pastime the entire family enjoyed. (THS.)

Lighthouse keeper Arthur Rider's wallet is part of the Tucker's Island collection at the Tuckerton Historical Society. Did he keep his wallet in his back pocket? Was it in his possession every day? What papers might it have contained? These questions will never be answered, but it is interesting to contemplate. (THS.)

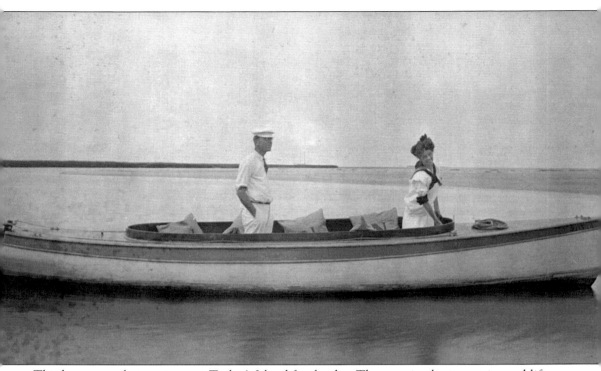

This happy couple is arriving at Tucker's Island for the day. The man is a boat captain, and life vests, lining the cockpit, provide peace of mind to those onboard the classic runabout. The man is holding on to a tiller with his left hand—though this is not visible. This boat may have been a catboat with mast converted to a faster-moving motorboat. Initially, catboats with their wide beam, classic looks, and large cockpits were used for fishing and transporting people and supplies around New Jersey's waterways. Sensing that their sailboats were becoming outdated, charter captains began to install automobile engines from broken cars in their sailboats. Masts were completely removed, or maybe a small stump was left to secure a bowline. The bowline on this boat is coiled around such a stump. (CE.)

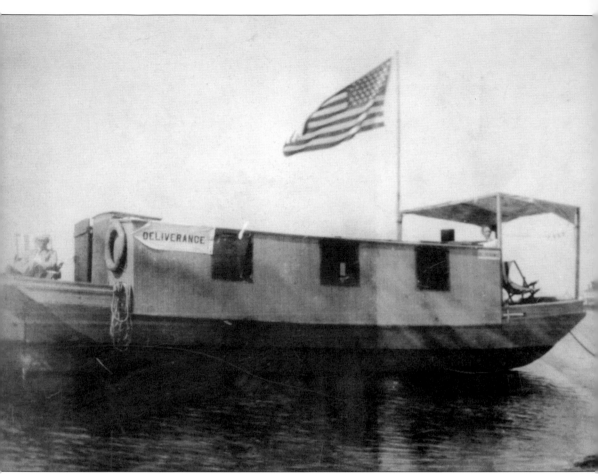

People along the Jersey Shore loved their houseboats. In this photograph, a man stands on the bow, which has two chairs for relaxation. He proudly flies his American flag. The boat's name *Deliverance* is crudely affixed to the cabin. To the far right stands the Tucker's Island Lighthouse. In addition to those who lived permanently aboard houseboats, people also used them for weekend fun. Houseboats were made of Atlantic white cedar with a room built on top of the barge-like structure. They could sleep anywhere from a small family to hunting parties of 14. Mostly without propulsion, they were pulled by garveys wherever they were intended to be placed. There was usually an outhouse at one end, food had to be purchased almost daily, potbelly stoves provided warmth, and clotheslines were strung wherever possible. (LBIHA.)

An unidentified man has tied his sneakbox (sailing rig) up to a houseboat. In high black boots, he looks as if he has just come in from hunting. If so, the houseboat people most likely have a fresh goose or duck to be roasted for dinner. Water was collected on houseboat roofs and contained in large barrels; the drain or tubing from the roof is seen here leading directly into the wooden barrel. However, houseboats had their detractors. Local communities complained of the lack of sanitary conditions where houseboat people gathered. On June 20, 1926, Beach Haven was the first town along the Jersey Shore to ban houseboats from its docks and local creeks. Some houseboats were then placed on islands in the bay as hunting shacks. Eventually, these were torn down by government order, set afire, or washed away with storms. (LBIHA.)

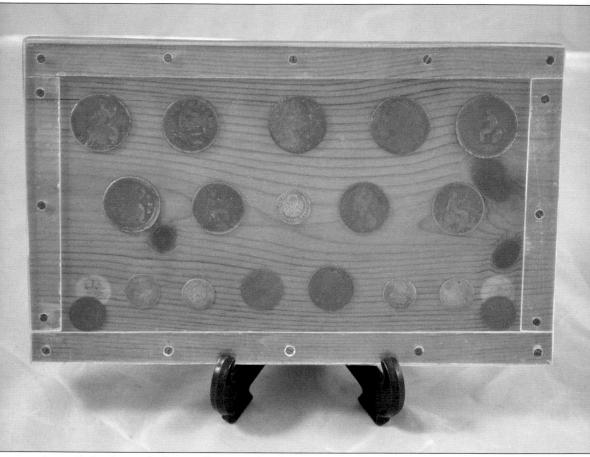

Leroy Rider donated a large collection of Tucker's Island memorabilia to the Tuckerton Historical Society. The following is found on the back of this coin display: "These coins were found after all was gone but the old schoolhouse owned by A. Rider." This would mean the time between October 12, 1927, and 1933. The Rider family spent time in the old schoolhouse Arthur Rider had moved to higher ground and converted into a small cottage. Other family members nostalgically took day trips to what was quickly becoming an eroding sandbar. Old coins, especially Spanish and English ones, are considered collectors' items. George B. Somerville writes in the *Lure of Long Beach* that "Spanish galleons, laden with the bullion, gold, silver, and other wealth passed along the Jersey Coast on their way to home . . . some were cast away on the shoals of Barnegat, and specimens of ancient coins have been washed ashore and found on the sands of Long Beach, particularly in the Old Inlet section, below the old Bond House." (THS.)

Children will be children, and Russell (whose name is also spelled Russel) Horner was no exception. He would clown around for visitors by telling them to throw quarters at him, which he would then pick up without using his hands or his feet—he instead would pick them up from the sand with his teeth. In long pants, a long-sleeved shirt, and high shoes, Russell explored the dunes and looked for shells and "treasures" washed up on shore by passing ships. His attire helped prevent New Jersey's annoying flies called greenheads from bothering him. Russell and his friends led a very different life on Tucker's Island during the summer months than those in mainland towns. Russell's parents, Arvilla and John, were co-owners of Skeeters. This photograph may have been taken at the Life-Saving station; rescue equipment lines the side of a sandy road, which, no doubt, led to the beach. (NRAS)

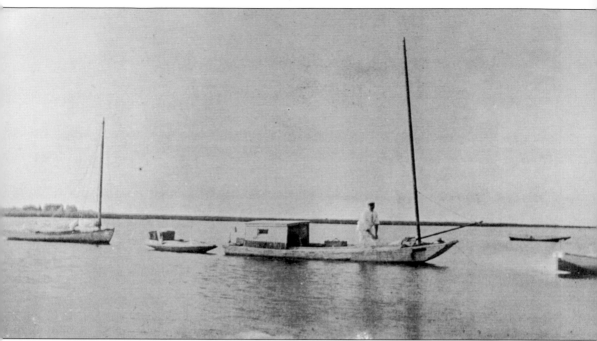

Boats of all types could be seen around Tucker's Island. A snub-nosed, flat-bottom garvey with staysail looks as if it has just anchored and still has a sneakbox and catboat attached from towing. Invented by Jarvis Garvey Pharo, it was a shallow-draft workboat with low freeboard. They were used for clamming and could easily be settled on marsh or sand. Once having had two masts for sailing, this one has had the aft mast removed, and an open cabin was constructed in its place. A duck boat, or sneakbox, is going to be used for hunting geese, ducks, and whatever else flies overhead. Oarlocks are visible on each side, enabling the hunter to maneuver into the marshes. Racks of decoys are on the stern ready for use. The last boat (on the left) is a catboat. A big sail is rigged to the spars but is furled to keep from blowing the sailboat off course. (LBIHA.)

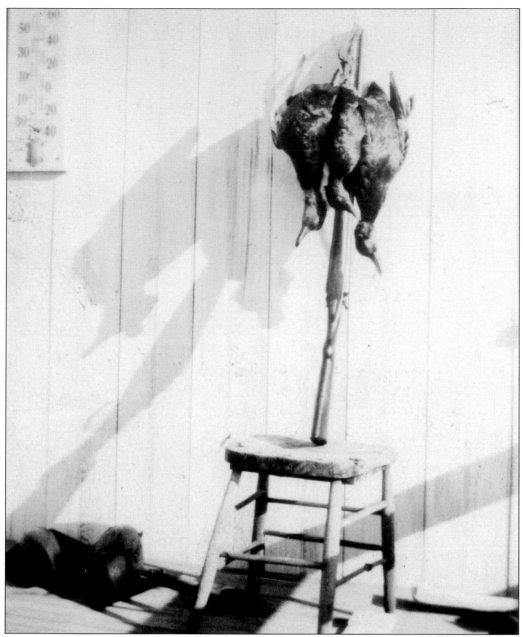

Tucker's Island inhabitants always had fresh food, though it might have been monotonous with a diet consisting primarily of fish and birds. Hunting was a daily activity, with geese and ducks the most common game. These were roasted or cooked in iron skillets on top of three-burner kerosene stoves. Potpies were made from small railbirds and the breasts of others. Year-round families had carefully tended gardens of basic staples, such as potatoes and onions. Green vegetables were grown and consumed during the summer months. Seafood was a daily staple as well. Harvests included clams, oysters, crabs, and many fish that were plentiful at the time. Essential items were brought by boat from the mainland on occasions when trips were made to Tuckerton. While families felt the hardships of living on the island, no one ever went hungry. This photograph is identified as "Pop's ducks." (THS.)

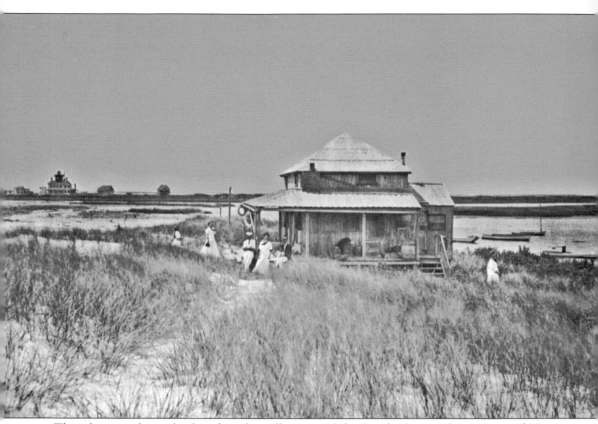

This photograph can be found in the collections of the Beach Haven Library, Jim and Nancy Speck of Tuckerton, and artist Cathleen Engelsen of Surf City, New Jersey. Skeeters was the name of the cottage that stood by the water on the southeast side of Tucker's Island. It was owned by the Jones and Horner families—Arvilla and John Horner and W.C. and Margaret "Pep" Jones—and the name came from the mosquitoes that could be found outside on summer evenings. A rain barrel can be seen on the right-hand side of the porch, complete with downspout leading from the gutters. Skeeters was used regularly by both families, and it was sometimes rented out to family friends and hunting parties. Dune grass and bayberry bushes surrounded three sides of the house, with narrow pathways in the sand leading to the lighthouse on the north end and other buildings. (CE.)

Landed and took possession
of the "Skeeters" — Aug 6/10
from
to Aug 20 Oct/10

Members of party as follows: —

G. F. Randolph	Tuckerton N.J
F. F. Randolph	" "
Nina Montfort Jones	Hammonton N.J.
W. C. Jones	Tuckerton, N.J.
Ruth Madeline Jones	Hammonton, N. J.
Margaret E. Jones	" "

Errol D. Horner — Tuckerton N.J
Florence Randolph Horner

Leaving Aug. 20, 1910.

Weather clear; atmosphere very
clear; wind NE.

A wonderful handwritten log of a house party at Skeeters starts as follows: "Landed and took possession of the Skeeters, August 10–August 20, 1910." It is recorded that the "weather was clear, atmosphere very clear, wind NE." Members of the Randolph, Montfort, and Jones families from Tuckerton and Hammonton, New Jersey, spent time exploring the island, fishing, and visiting friends on the island. Walking was the only method of transportation; people walked on the sand along pathways carved out by continued use. Sitting on a porch that surrounded three sides of the cottage, visitors would let their legs hang over the edge into the dune grass. Evenings were spent inside, away from the bugs, reading, playing cards, or just visiting. Kerosene lanterns provided light. The last notation on the log reads, "Leaving, August 20, 1910." (CE.)

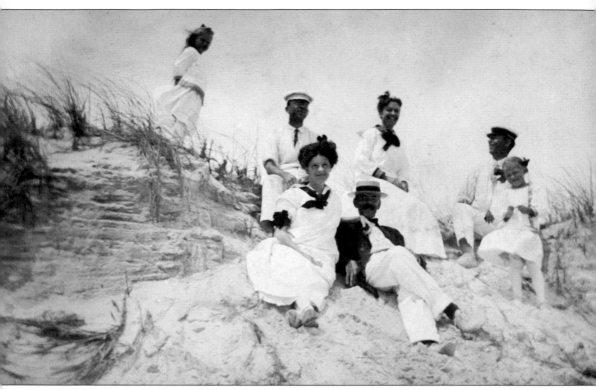

A photograph of this happy group, posing in the dunes at Sea Haven, was taken the day W.C. Jones and his wife, Margaret "Pep," bought Skeeters. That day was July 15, 1910; the group consists of Horner and Jones family members from Tuckerton and Washington, DC. W.C. was an avid photographer, which was unusual for his time. His photographs, now owned by renowned artist and granddaughter Cathleen Engelsen, show happy people enjoying special moments with families and friends. A log recording from July 15–18 shows changing weather from "clear and warm" to "heavy thunderstorms at 10pm" and "wind shifting to north in heavy squall." People who lived at Sea Haven planned their days according to the weather, which dictated all activities. Trips across Little Egg Harbor in rain and heavy seas might have been acceptable for hardy men, but they were not for families with women and children. (CE.)

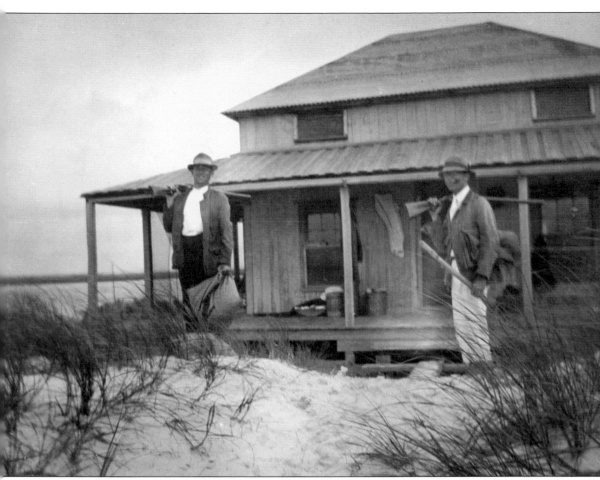

Two unidentified men are set for a day of hunting and relaxation. With shotguns and bags for their catches, they are happy to be spending time away from work. Hunting could be done from most anywhere on the island except for around the Life-Saving station and lighthouse, where there were always people. There were no ownership problems or territorial restrictions. Sea Haven was a welcoming place for all who appreciated the outdoors. Skeeters was built directly in the sand on low footings. A loft with iron beds and horsehair-filled mattresses held the weary each night. Downstairs was a large room for gatherings, eating, and cooking. Eel-grass insulation in the walls helped ward off wind and cold to some extent. Makeshift shelves with books lined one wall. It was the perfect destination for a summer vacation. (CE.)

John Winfield Horner was proprietor of Horner's Grocery Store on Main Street in Tuckerton. Dapper in his three-piece suit with dangling watch fob, he gave the appearance of a consummate businessman, but he loved being on Tucker's Island. A 1925 *Times Beacon* local news column reports that "J.W. Horner took a week's vacation spending time down in the bay." (NRAS.)

Arvilla Mott Horner was a beautiful lady. Arvilla and John Horner spent many days at Skeeters, which they owned jointly with W.C. Jones and his wife, Margaret. Arvilla poses in a Victorian chair, clad in fancy coat with fur collar, wearing pearls and an appealing hat. She was active in the Methodist Church of Tuckerton. Both Horners are buried in Greenwood Cemetery, Tuckerton. (NRAS.)

W.C. Jones and his wife, Margaret "Pep" Jones, pose for a formal picture. They owned Skeeters for a time, and Jones is known for photographing life on the island. They are the grandparents of renowned artist Cathleen Engelsen of Surf City. Cathleen paints Tucker's Island scenes using her grandparents' photographs of the island. With actual photographs clipped to her easel, she has an acute eye for accuracy. W.C. owned two stores in the Tuckerton area. An ad in a 1921 *Times Beacon* describes his inventory as follows (with original spellings): "At our two stores you will find a nice stock of crockery, hand painted china, glassware, games, music rolls, Victrola records, Pyrex ovenware, Community silver, ladies wrist watches, jewelry, clocks, cut glass perfumes, toilet articles, stationary, confectionary, Kodaks, cameras, film, post cards, paper goods, and dinner sets." (CE.)

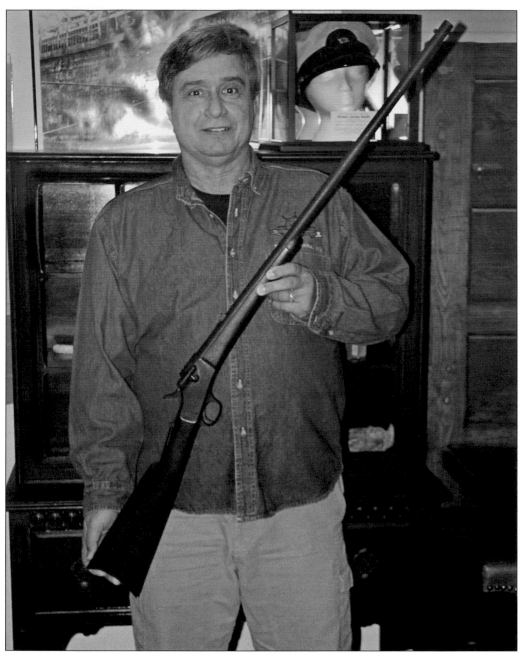

Jim Vogel, executive director of the New Jersey Maritime Museum in Beach Haven, holds Arthur Rider's rifle. Donated to the museum by Shirley Burd Whealton of Tuckerton, this 1910 Phoenix .44-caliber rifle was probably used for protection, and not for hunting birds and small game. This big-bore rifle is rusty, and the firing pin is missing. It is completely disabled and unable to be fired today. With a stretch of one's imagination, it is easy to picture keeper Arthur Rider facing unknown men on the beach of Tucker's Island. "State your names, state your purpose," he might have said. It took extreme courage to be the authority on Tucker's Island. His only comrades in dealing with questionable or unsavory characters were his son, station keeper Jarvis Rider, and the men of the US Life-Saving Service/Coast Guard. (NJMM.)

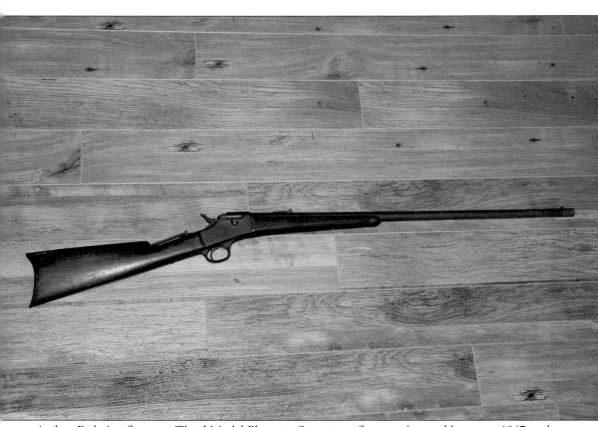

Arthur Rider's rifle was a Third Model Phoenix Sporting rifle manufactured between 1867 and 1881. It is a single-shot breech-loading rifle and .44 caliber and was made for the civilian market by the Whitney Arms Company of New Haven, Connecticut. Eli Whitney (inventor of the cotton gin) founded the Whitney Arms Company, but his son Eli Jr. owned the company at the time of this gun's manufacture. Ownership would transfer to Winchester in the late 1800s. A shotgun would have made better sense for keeper Rider to use, and possibly he had one. This was a rifle for civilian use. Whether it was used for protection or hunting is up to one's interpretation, but one expert says protection would have been its primary use. (NJMM.)

This gentleman is having a picnic on the beach in front of Skeeters, shown in the background. An open book lies by his feet. Note the bottle and remains of food at his side. This is likely a happy man, enjoying his time on an unspoiled and untamed island. (CE.)

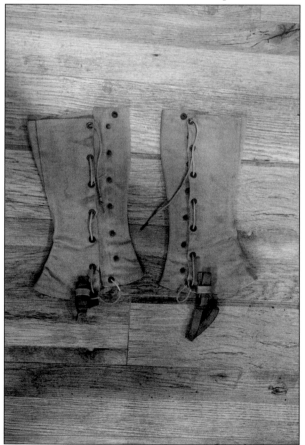

Keeper Arthur Rider's puttees are on display at the New Jersey Maritime Museum. According to the *Merriam-Webster Dictionary*, puttees are "cloth strips that wrap around the legs from ankles to knees." They were perfect for traversing Tucker's Island, a wilderness of scratchy grasses resulting in leg cuts, or bushes like rugosa roses, which have thorns that routinely break the skin. These were donated by Arthur's descendant Shirley Whealton. (NJMM.)

Five

A Cast of Characters

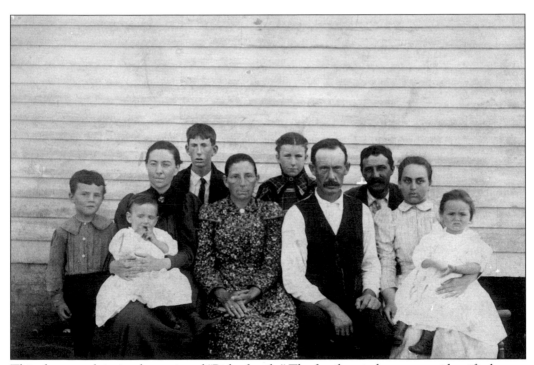

This photograph is simply captioned "Rider family." The family members are not identified—nor is the location, though it must have been on Tucker's Island to get so many together for a family shot. The Rider family was very large. It is interesting to note that while the Riders spent their lives on Tucker's Island, births, marriages, and deaths were recorded on the mainland in Tuckerton. (THS.)

This is the only existing photograph of the Rider family to have been taken in 1890. Lighthouse keeper Eber Rider Sr. was still in charge; son Arthur did not take over until 1904. Family members are, from left to right, (first row) three unidentified children; (second row) three unidentified people, Hilyard Rider, and two unidentified people; (third row) unidentified, Arthur Rider, Eber Rider Jr., Nancy Lippincott Grant Rider; (fourth row) Maryann Cranmer Rider, Eber's wife; keeper Eber Rider Sr.; unidentified; and Jarvis Bartlett Rider. The Rider family was such a large and extended one that descendants have had difficulty identifying their ancestors. Sons, brothers, nephews, and cousins worked at either the lighthouse or the US Life-Saving station. Shirley Burd Whealton spent years compiling her Rider family genealogy, a copy of which may be viewed at the New Jersey Maritime Museum. (GH.)

Hilyard Rider was a son of keeper Eber Rider Sr. He is listed as Mary and Eber's 16th child. According to Shirley Whealton's family tree, his full name is listed as John Hilyard Rider. Hilyard was born in Tuckerton (where most of the Tucker's Island Rider wives went to have their children) on September 17, 1869, and died at Sea Haven on June 25, 1910. (GH.)

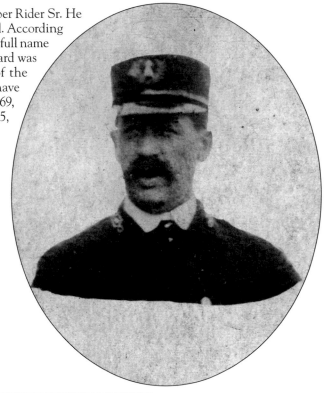

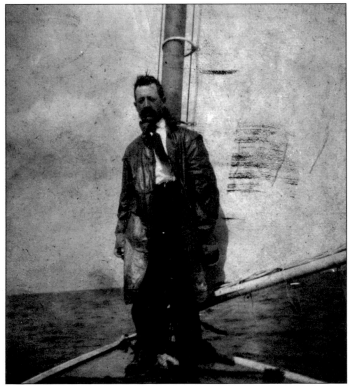

In this photograph, Hilyard Rider poses against the mast of a catboat. Hilyard was an assistant keeper at Tucker's Island when his father was dying. He was active with the Lighthouse Service until his death. He was a member of the Odd Fellows, Knights of the Golden Eagle, and Junior Order of United American Mechanics. Funeral services were held at the home of his brother Anson J. Rider, and his interment was at Tuckerton. (GH.)

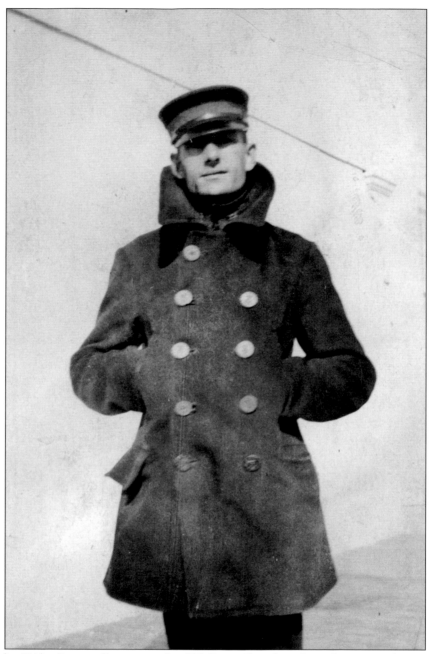

Leroy John Rider Sr. proudly poses in his US Coast Guard uniform. Leroy was the son of Eber Rider Jr. by his first marriage to Nancy Lippincott. Leroy was born on February 9, 1898, in Little Egg Harbor, and he and his brother Charles spent much of their lives in Easton, Pennsylvania. Leroy proudly served in the Coast Guard during World War I from 1918 to 1921. His obituary reads, "He was an inspector in the Readington, PA fuse plant from 1916–1918. For many years he was a painter, working for Gordon Bennett, Easton. He was a member of St. John's Lutheran Church; a life member of the West Easton Athletic Club; a member of the West Easton Safety First Fire Company; and the Fraternal Order of Eagles, Easton. Surviving are his wife Julia, son Leroy Jr., daughter Mrs. Kathleen Enger, three grandchildren, and four great grandchildren." (THS.)

Tuesday 12,

Am writing to tell you we had a Phone put in yesterday, The number is Tuckerton 3 R 3

Dont know yet when we will get to Easton, Shallder expects to finishe his Job in a few days — We may get up some time next month AHT

Tell Charlie about the Telephon

Roy Rider
313 Second St
W. Easton Pa

THIS SIDE OF CARD IS FOR ADDRESS

Leroy "Roy" John Rider Sr. receives a postcard from Tuckerton saying that a phone had been installed in the home of his uncle and aunt Arthur and Florence Rider in 1937. It must have been an exciting event. Postmarked January 12, 1937, and addressed simply Roy Rider, 313 Second Street, West Easton, the left front of the postcard reads, "Tell Charlie about the telephone." In his retirement (sadly, he died two years later), Arthur Rider could enjoy things he had not experienced before. Leroy and his wife, Catherine Miller, whom he had married in Freemansburg, Pennsylvania, on July 2, 1921, were close to Arthur. Leroy was a frequent visitor to Sea Haven, though there is no record or photograph of Catherine ever having set foot on the island. Leroy loved hunting, fishing, and exploring Sea Haven. He spent hours walking the island collecting whatever washed in after storms. (THS.)

Leroy Rider Sr. carved a small ship model from a porch post of the Tucker's Island Lighthouse. All the men carried knives and carved decoys or made ship models. Wood from wrecks littered the beach. In spite of long work hours and many duties, there was leisure time to pursue favorite pastimes. Men and women read, played cards, and had impromptu parties singing and dancing to a gramophone. (THS.)

"I made this boat out of a porch post from the lighthouse after it (came) down," Leroy Rider Sr. wrote to his son Roy. "I made it one time when I was down to Uncle Arth's bungalow." Leroy does not remember the exact year. There were only a few years after 1927, when the bungalow was moved to higher ground, before it washed away. (THS.)

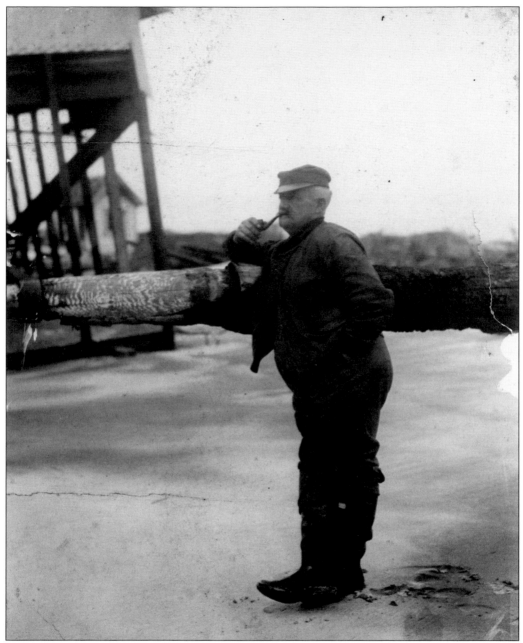

A pensive keeper Arthur Rider leans against a large schooner mast that has burned. Margaret "Pep" Jones took this photograph. This photograph has been in the New Jersey Maritime Museum collection since the popular museum opened eight years ago and is unmarked except for the photographer. There is no clue as to the fate of the ship, which lost its mast. Obviously there was a fire aboard. Keeper Rider has his trusty pipe in his mouth. In the background is a house built high off the ground, yet not on pilings. The cottage foundation is wood laid directly on the sand. It is curious that not even Atlantic white cedar pilings were ever used on Tucker's Island. A storage shed is visible through the cottage. (THS.)

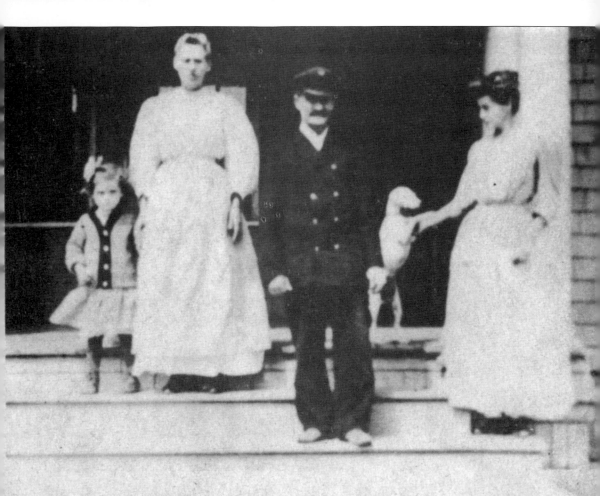

AT THE LIFESAVING STATION — Keeper Capt. Jarvis Rider poses on the steps with little Gertrude Stiles and her grandmother Mrs. Flossie Stiles while Mrs. Rider plays with their dog Topsy.

An unidentified newspaper clipping shows a photograph of station keeper Jarvis Rider (center) with his first wife, Rebecca E. Mott Rider, playing with their dog Topsy. Little Gertrude Stiles is on the left holding onto the hand of her grandmother Flossie Stiles. Gertrude is adorable in her flowing short dress, fashionable sweater, and large hair bow placed on one side of her head. Jarvis looks about 40 in this undated photograph, so the year must be around 1890. There were a number of dogs on the island, and they all looked alike. All were mixed breeds, and they obviously thrived living outdoors most of the time. They were fed scraps and leftovers from seafood and duck and geese dinners. Dog food was not yet available; nor could the families on the island have afforded such a luxury for their pets. (LBIHA.)

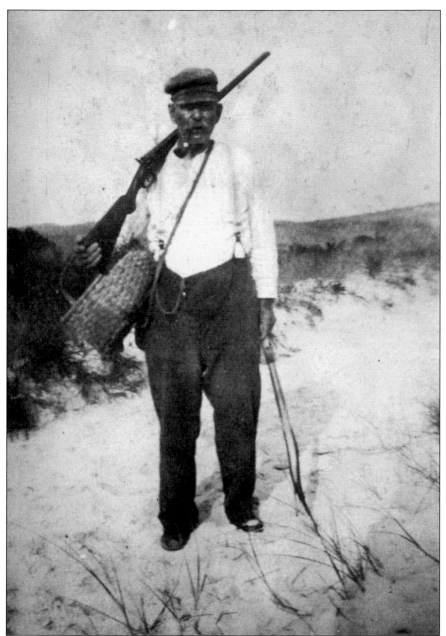

According to a 1922 issue of *Bird Lore*, an illustrated bimonthly magazine devoted to the study and protection of birds, "Samuel P. Cramer of Tuckerton guarded the Life Saving Station beaches and adjacent marsh where thousands of Laughing Gulls and hundreds of Clapper Rails reared their young. Twenty five pairs of Black Skimmers also occupied the colony this year." This is the first mention of any sort of conservancy or protection of the wildfowl on Tucker's Island. It had always been assumed that families hunted primarily for food, not sport, taking only what they needed. The man pictured is identified as "Uncle" Sam Cramer; whether he had married into the family or was given the title of uncle as a term of affection is unknown. He was born on June 9, 1887, married Sarah A. Berry Adams, died on December 3, 1935, and was interred in Greenwood Cemetery, Tuckerton. (NRAS.)

An attractive young lady takes the helm of the *Arvilla* on a ride to Sea Haven. She is standing on a box to see over the cabin. "Sis" is the mother of Nancy Speck, a Tuckerton resident, whose family photographs have been invaluable to this book. Sis's real name was Leah Arvilla Horner Marr. She was born in Tuckerton in 1911. In a 1995 booklet for the Barnegat Bay Decoy and Gunning Show, Sis's life on Sea Haven is remembered: "Every year for the entire summer, her whole family would pack up and take a boat over to Sea Haven. There she would spend her childhood doing what every child dreams of – swimming, beachcombing, climbing the lighthouse to look out over the island, and walking the beach looking for treasures that might be cast aside. Her dad would spend weekends with his family because he owned Horner's Grocery Store." (NRAS.)

The two adorable children in this photograph belonging to Nancy Speck are Russell Horner and his sister Leah "Sis" Horner. The children are ready for a day of climbing and sliding down the Sea Haven dunes, searching for crabs in the mud, and pulling out clams with their toes. It is one of the few photographs showing children barefoot, as children should have been while playing on Tucker's Island. Both are in shorts. Russell has on a wool tank top, and Sis has on a middy blouse. Russell looks like the little devil he was, while Sis is ready to follow whatever her older brother suggests. They are standing on the walkway on the side of the Tucker's Island Lighthouse. This is the only photograph known to show an island walkway of part cement, part brick. An unidentified cottage appears in the right-side background of this photograph. (NRAS.)

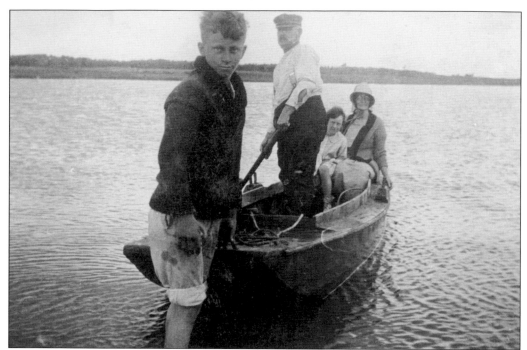

Russ Horner holds on to the bow of keeper Arthur Rider's garvey, Rider mans an oar, and Sis and her mother sit in the stern. Sis went to Tuckerton Elementary and Tuckerton High School. She married Belford Taylor Allen, a bayman and dredge operator; they lived on the dredge and sold clams. She helped sort them for sale. The Allens' other boat was named *Arvilla*, Sis's middle name. (NRAS.)

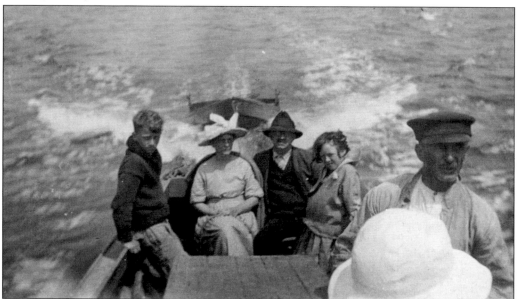

Everyone in the Horner family was in good spirits when they were in their garvey, the *Arvilla*. Russell Horner leans against the cockpit rail wearing a heavy woolen sweater. Sis is in the same position on the right. In nautical terms, Russ is on the starboard side of the boat and Sis is on the port side. In between are their parents. Capt. Lil' Dick Mottram is at the helm. (NRAS.)

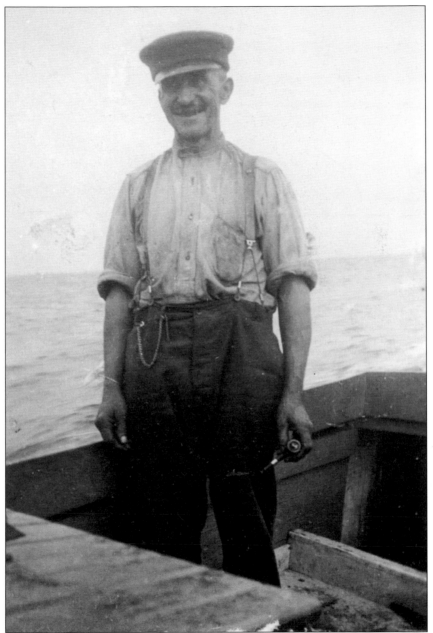

Lil' Dick Mottram was happiest as captain of the Horner family's garvey *Arvilla*. He lived with the Horner family in Tuckerton for many years. Suspenders held up his black wool pants over an old Henley shirt with rolled-up sleeves, and a pipe is held in his hand. His wide smile shows a man who loved being a bayman, a man who made his living off the bay, harvesting different seafood according to the season. Clams, oysters, scallops, crabs, and fish were commonplace. Eels were caught in Tuckerton Creek with eel spears, mainly in the winter months when these fish were lethargic. Traps were also set with horseshoe crab meat inside. Eel was best fried, dropped into hot skillets where they would squirm to the horror of people who had never seen them cooked before. Most people lived off the land and sea; store-bought food products were not affordable for every meal. (NRAS.)

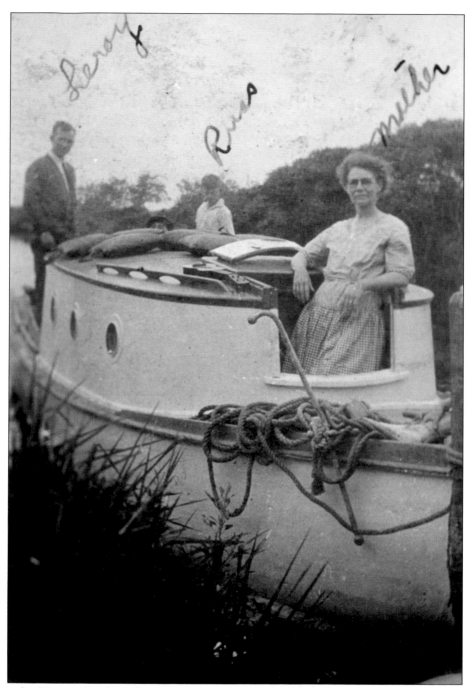

Either the Horner family took numerous pictures of the family boat *Arvilla*, or people were so enamored of their garvey that everyone wanted a photograph of the boat. This was at a time when photography was just becoming popular. In this undated photograph, the *Arvilla* is anchored at Sea Haven with family members aboard. Someone is sitting on the motor box, which acts as a seat for several people. Garveys were first sailed, usually with two masts, but baymen later added old motors from broken-down Ford Model Ts to the center of the boat for propulsion. Boxes were built around the motors so passengers would not get hurt or burned. (NRAS.)

Arvilla Leah "Sis" Mott Horner, grandmother of Nancy Speck of Tuckerton, uses binoculars on the porch of the Tucker's Island Lighthouse. A striking lady with a trendy Gibson girl hairdo and slim waistline, Arvilla is wearing a lightweight summer cotton dress that flows in the breeze. The low, one-rail fence that surrounded the perimeter of the lighthouse is seen is the background. (NRAS.)

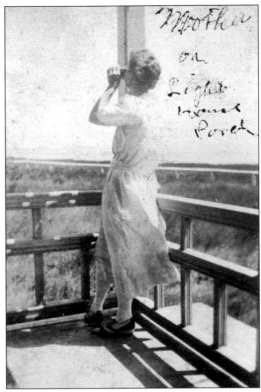

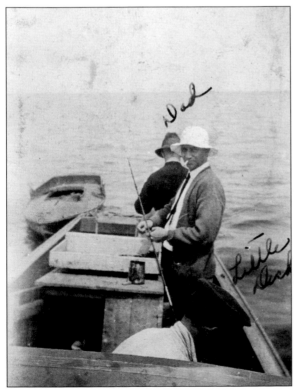

Fishing was in the blood of the Horner and Mott families. In this photograph, George Mott is hoping to land a fish before arrival. Captain Lil' Dick is kneeling in the *Arvilla*. (NRAS.)

Leroy Horner stands on the Sea Haven mudflats wearing high rubber waders. Leroy loved Sea Haven. He would visit his family in Tuckerton whenever he could take time off from work. He would then go to Sea Haven by boat to relax and see other family and friends. (NRAS.)

This photograph was one of the last ever taken of the sandbar Tucker's Island had become. In 1949, Leroy Rider Jr. visited with his uncle Charlie Rider, who had never been photographed on the island before. With the lighthouse gone in 1927, the Life-Saving station in 1933; and cottages and other buildings by the late 1940s, there was not much left of what had once been Sea Haven except a large sandbar at low tide. (NRAS.)

Six

US Life-Saving Service/ Coast Guard Station

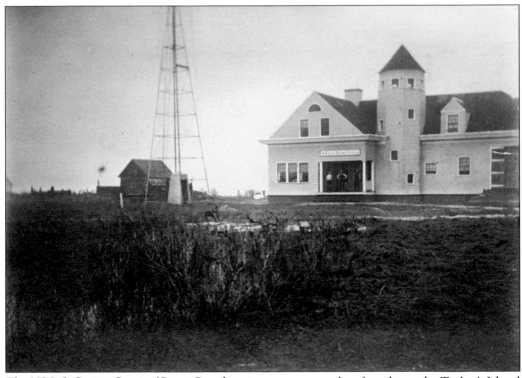

The US Life-Saving Service/Coast Guard station was commonly referred to as the Tucker's Island Life-Saving Station No. 119, although it was officially the Little Egg Station. The first station keeper was Thomas W. Parker, who was appointed in 1856. He held his position until Jarvis Rider was appointed in 1869. (NJMM.)

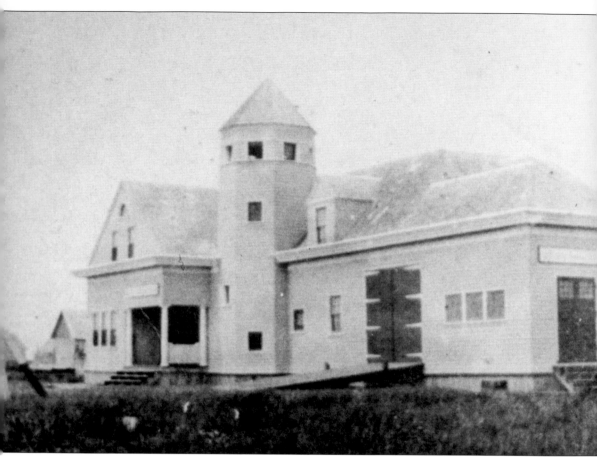

This is one of the older photographs of the Life-Saving Station No. 119 on Tucker's Island. It was taken before areas were cleared for lifesaving drills and prior to the construction of bungalows and buildings needed to store equipment. Keeper Jarvis Rider went on to serve a distinguished 46-year career. After retirement, he wrote, "I have done my best and lost no man in my crew, nor a sailor that ever got in my surfboat. I give God thanks for my success. He has surely helped me in my life's work." (NJMM.)

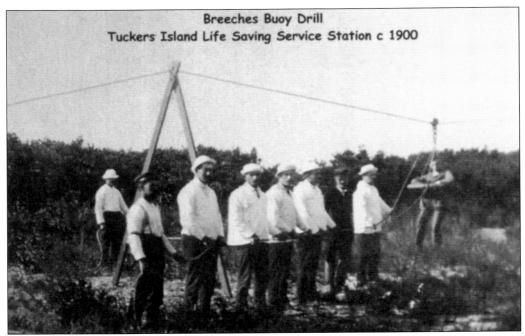

Breeches Buoy Drill
Tuckers Island Life Saving Service Station c 1900

This photograph is labeled "Breeches Buoy Drill 1900, Tucker's Island Life-Saving Station Circa 1900." Maritime historians face a confusion of names and titles when studying the island. Tucker's was always called the Little Egg Station. In 1936, Station No. 119 was moved to the meadows east-southeast of Tuckerton along Shooting Thorofare. The site was purchased from the Wharton estate. (LBIHA)

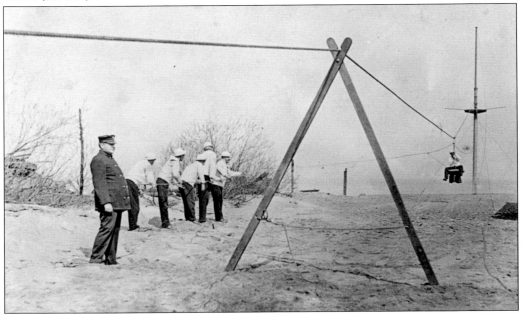

The breeches buoy drill was practiced often. Attached to a rope and pulley connecting a ship to the shore, mariners could be rescued one at a time, pulled to safety in a life ring with a pair of pants or britches (hence breeches). Evelyn Suter remembers that she and other children of the lifesavers were put into the breeches buoy and hauled from one spot to another. (NJMM.)

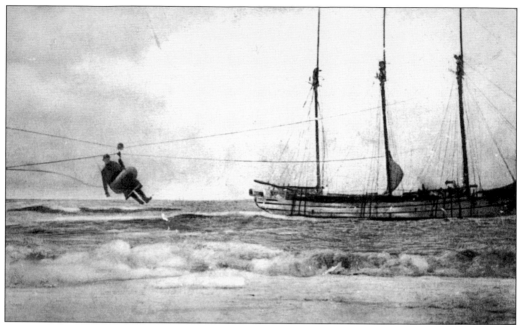

An unidentified three-masted schooner sits on a sandbar off Tucker's Island. Someone is in the breeches buoy—either a lifesaver going out to the ship or a passenger or mariner being rescued. Most of the canvas sails are neatly tied down. The seas look to be just a little rough. (NJMM.)

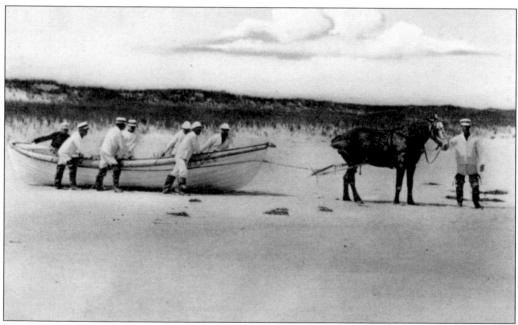

Harry, with tail swishing to keep off the flies, pulls a lifeboat during a rescue drill on the island. Men of the US Life-Saving Service are clad in summer uniforms with high boots. Government funding did not satisfy the need for men and equipment, no matter where the stations were throughout the United States. Regular drills were conducted to ensure efficiency. (NJMM.)

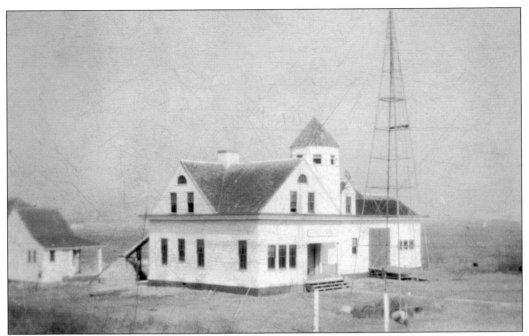

This historical photograph depicts the Little Egg Station during the summer months. Windows are open throughout the station and in the tower. There do not seem to be any screens; the abundance of green and black flies can only be imagined with horror. This photograph looks to have been taken around 1900. Station keeper Jarvis Rider would have been in charge. (NJMM.)

A Coast Guard vessel patrols among the boats anchored off Tucker's Island. This photograph is labeled "Arthur/Eber Rider boat and Coast Guard." Station keeper Jarvis Rider is probably aboard one of the vessels. Scenes like this, with a Coast Guard vessel patrolling local waters, were daily occurrences during Prohibition, which lasted from 1920 to 1933. Coast Guard crews continually patrolled Little Egg Inlet in a cat-and-mouse game to see who would win. Rum-running local captains came in Little Egg Inlet, headed for either Leeds Point, Tuckerton, or north to Beach Haven, where thirsty buyers would pick up a week's supply of bourbon or Cuban rum. Prohibition was an era when boat captains were pitted against the Coast Guard; sometimes, Coast Guardsmen were rumrunners themselves. (NJMM.)

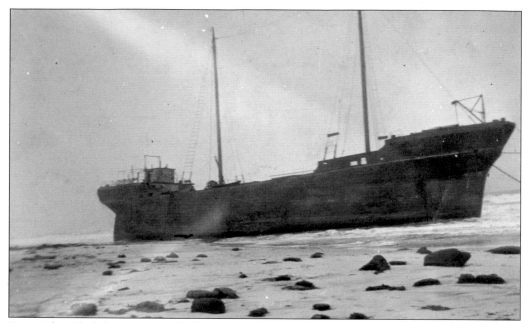

An unidentified ship is aground off Tucker's Island. The cargo steamer, or converted barge, was no doubt part of the coastal trade, where many ships passed directly off the Jersey coast on a daily basis, trading from Caribbean islands north through Maine. Viewed from the beach, this old schooner is huge. (THS.)

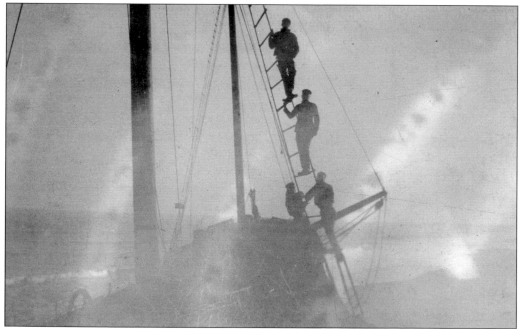

Members of the US Life-Saving Service/Coast Guard climb the rigging to pose for a picture aboard a former two-masted schooner. Neither the year nor identity of this ship is known. Rather than abandon an old schooner, owners converted them into barges, which were used strictly for towing. Coal was a popular cargo. Surprisingly enough, there were no regulations about towing of barges by steam tugs, which led to barges breaking loose. (GH.)

A wooden chest sits in the Tuckerton Historical Society. Washed ashore from an unidentified ship, this unidentified carpenter's chest had once been full of tools. It is handmade, most likely crafted by the carpenter himself. There is a divider inside, and little diamond ornamentation are on the front. This chest was found by Leroy Rider Sr. and donated to the Tuckerton Historical Society by Leroy Rider Jr. (THS.)

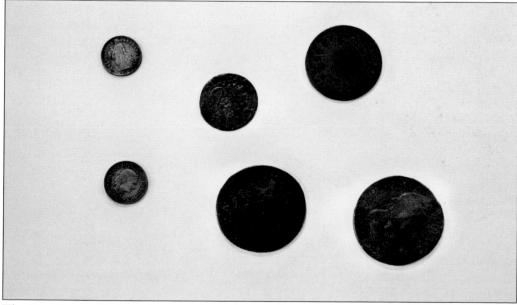

The New Jersey Maritime Museum has a large collection of artifacts found in the vicinity of Tucker's Island. Most cannot be specifically identified. Beachcombers and metal detector enthusiasts find coins from faraway lands on a regular basis. (Photograph by Shannon Weaver Photography, courtesy of NJMM.)

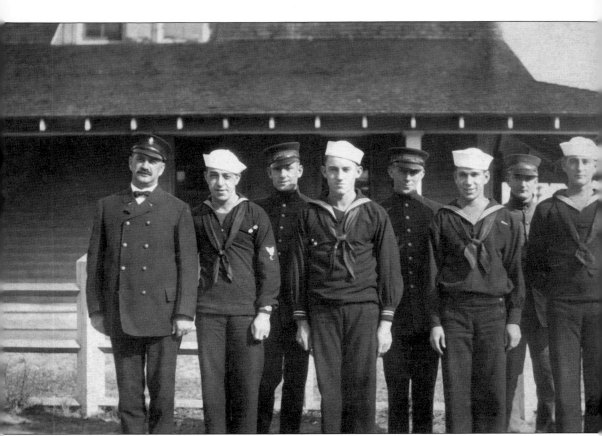

These men are identified only as "crew of the ship." CDR Timothy Dring, US Naval Reserve (Ret.), a Coast Guard historian, thinks this photograph was taken during Prohibition, sometime from the early 1920s to the early 1930s. He notes, "The surfmen are still wearing their WWI period uniforms with high-buttoned collars, and the men in the classic uniforms were probably off one or more patrol boats/picket boats that were assigned to Tucker's Island during the height of the Prohibition enforcement period. These sailors were not surfmen, but were only assigned as crew to the larger boats and cutters. By the mid 1930s, the uniforms for both surfmen and cutter/boats changed." The uniform styles of single- and double-breasted frock coats and hat brim styles are vestiges of the old US Life-Saving Service, but they were mixed with the arm insignia and open-collar blouses that are more indicative of the early 20th century. (THS.)

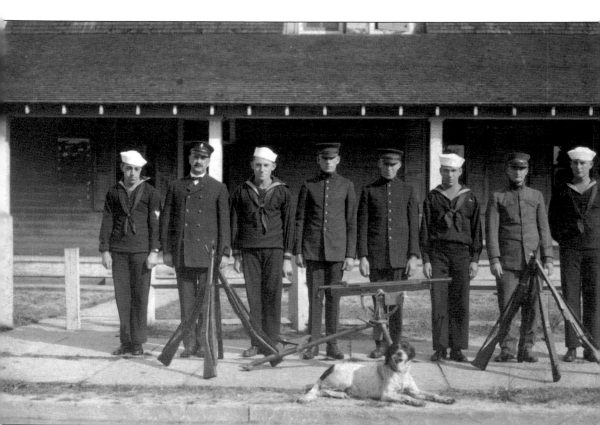

An antique firearms expert explains the display of guns standing in front of the "crew" as a show of force. These men are from a Coast Guard ship that stopped at the Sea Haven Coast Guard docks. Taken at the same time as the photograph on the opposite page, the photograph most likely dates from between 1921 and 1931. The Coast Guard was originally an armed service, and the stands of arms in front appear to be Model 1903 Springfield bolt-action rifles; and the gun on the tripod is definitely a Model 1895 Colt-Browning automatic machine gun. This was the first machine gun adopted by the US military and first saw action in the Spanish-American War in 1898. It was obsolete by 1921. As for the dog lying in front of the group, he was probably owned by a member of the Little Egg Station No. 119 at Sea Haven. (THS.)

Men of the US Life-Saving Service/Coast Guard survived and thrived on the island, which was miles from the mainland, with the help of hard work and a little entertainment. One form of entertainment was music. Self-taught musicians played their harmonicas, ukuleles, mandolins, and banjos. The station had a big room that held all of the island's families. Together, they sang along to the music and danced. (THS.)

Taken at the Life-Saving station, this photograph depicts an unidentified group of surfmen. They are either enjoying their off-duty time or are attired in off-duty clothing in order to clean up an old boat. A bike leans against the station porch. Bicycles were used at many Life-Saving stations; they were a cheap mode of transportation. In spite of the sandy roads, they could be easily maneuvered when air was deflated from the tires. (THS.)

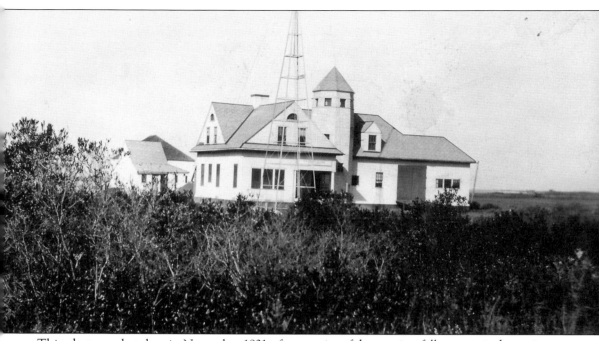

This photograph, taken in November 1931 after a series of devastating fall storms, is deceptive. The official Coast Guard photograph, dated November 8, 1930, has the following caption: "General view of ocean front (SE) of station building." The photographer was standing on high ground in the midst of thick bayberry bushes. Half of the leaves are still on the branches in spite of frequent storms. Viewing the Little Egg Station flanked by healthy looking greenery, it is hard to imagine the end had come. The boathouse door to the right of the building is intact, and the tower is standing straight. Margaret Bucholtz, in *Great Storms of the Jersey Shore,* writes, "It was in the 1930s that the entire Northeast was to be reminded forcefully of its vulnerability, of the toll nature takes for living on or by its seas, of the power that moving air and fluid water can bring to bear on less flexible objects like beaches and buildings." (NJMM.)

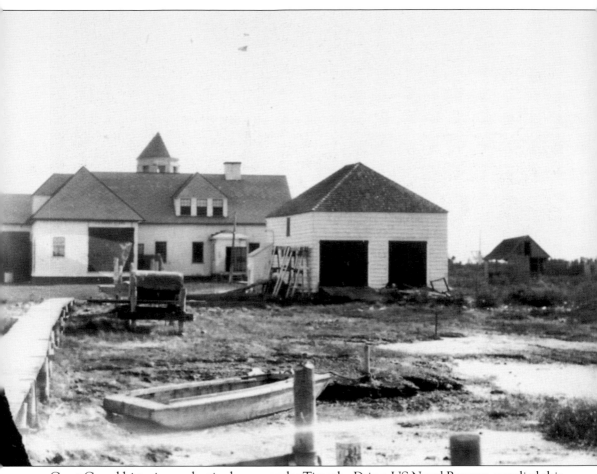

Coast Guard historian and retired commander Timothy Dring, US Naval Reserve, supplied this photograph. It is dated November 8, 1930, with the following Coast Guard caption attached: "View of rear station buildings from landing on bay shore." There has been a wash over of water around the building. Erosion has taken place. The ramp leading to the big doors where the surfboats were stored, along with other rescue equipment, is just about gone. Flotsam and jetsam block the right bay door and litter the yard. A small work garvey remains tied up to a piling, though deserted after many years of work. In the center of this photograph, it seems as if the rear door to the Little Egg Station has blown open. Walls have been washed away from buildings to the right. The windows in the octagonal tower look to have been blown out. A rack for sneakboxes and small work vessels at the end of the dock has been damaged and pilings uprooted. (NJMM.)

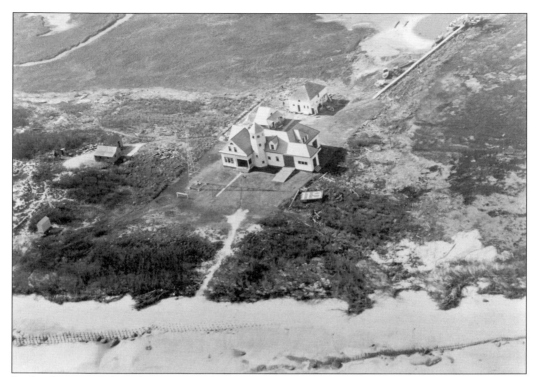

In this low aerial shot, damage is evident everywhere. The remains of wreckage from the ocean and debris from buildings cover the island, except for the area around the Little Egg Station, which had been graded a little higher. Most disheartening is the No. 119 sign (center forward), which had identified the Little Egg Station since it was constructed in 1855; it had blown off the roof in the November 1930 storm. (NJMM.)

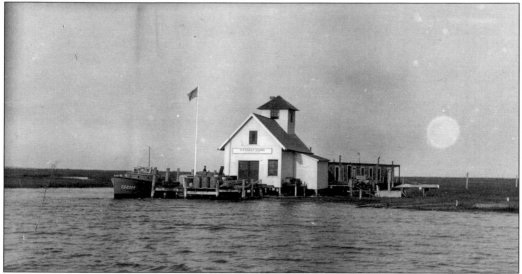

In 1934, a temporary Little Egg US Life-Saving/Coast Guard station was built in the meadows along Shooting Thorofare outside of Tuckerton. This official Coast Guard photograph shows an existing houseboat in the back. It was used a short time until the 1936 permanent station was built nearby. (NJMM.)

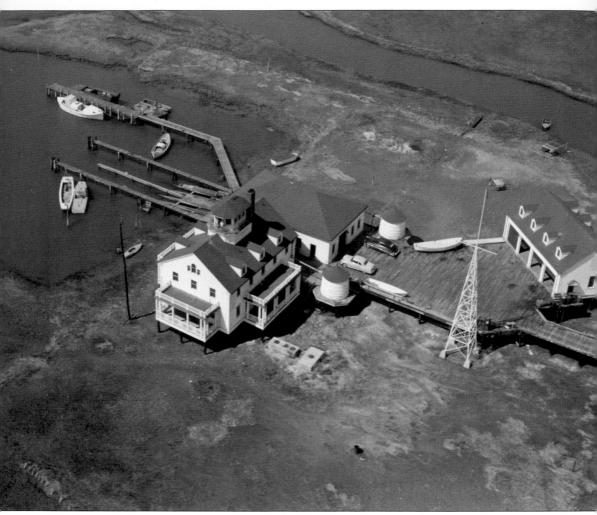

The Little Egg Station was started on March 31, 1936, and completed in December at a cost of $56,200 for the building, boathouse, and launch-way. It was designed to house 10 men and an officer. It is located at Seven Bridges Road in Tuckerton. At one time, the road was designed to cross over to Little Beach, an island south of Tucker's. It was the site of the Little Beach US Life-Saving/Coast Guard Station No. 120. The plan, initiated by Sen. Thomas Mathis and backed by the Ocean County Freeholders, was to have a road that went the length of New Jersey through marshes and over water. Between 1932 and 1937, pilings were sunk into the mud only to disappear forever in the muck. This station was eliminated as part of a Coast Guard consolidation effort and is now owned and operated by Rutgers University as a marine field station. (NJMM.)

Seven

A School and Scammers

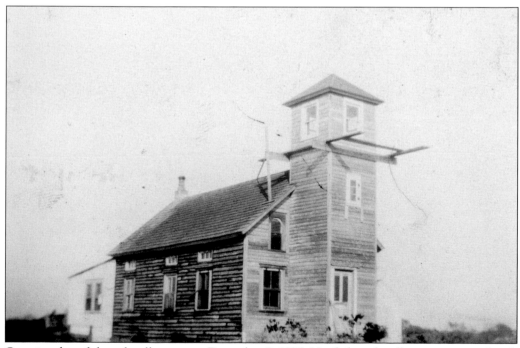

Opening day of the schoolhouse was December 9, 1895. Until the schoolhouse was completed, classes were originally taught to the handful of students in the Life-Saving station. Florence Morse of Waretown was the teacher. (THS.)

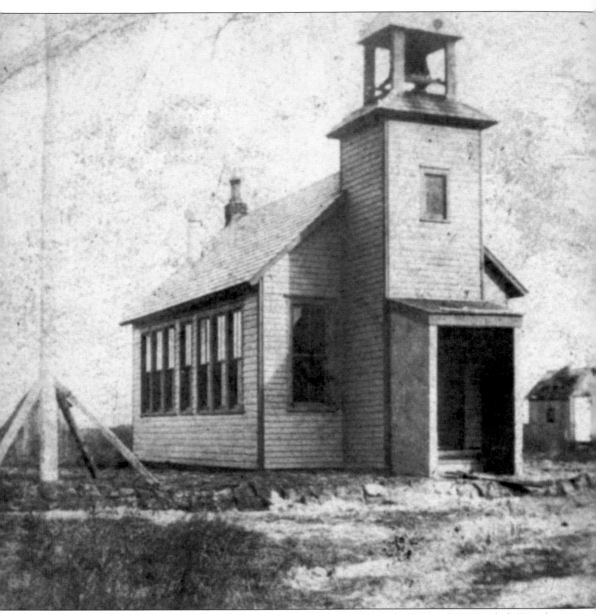

Like many buildings on Tucker's Island, the school was built and rebuilt when needed. Weather on the barrier island took its toll over the years, leaving weather-beaten boards loose and blowing in the wind. On the mainland, cedar siding and shakes might be conditioned with fish oil; but on Tucker's Island they were left untreated, at the mercy of gale force winds and pounding rain. Evelyn Suter mentioned, "My playground was between the lighthouse at the north end and the Life-Saving station three quarters of the way south on Sea Haven. I walked a mile to school." Every child walked; there was no other way to get to school. The children of Eber and Mary Rider walked south to the school, while the children of the surfmen of the US Life-Saving Service walked north. Both teacher and students crowded around the potbelly stove during cold weather. (THS.)

The schoolteachers at the Tucker's Island School had graduated from college/teaching school and were certified. A large bell was placed in the belfry over the front door. Mischievous boys were said to have climbed up and rung the bell on occasion. (LBIHA.)

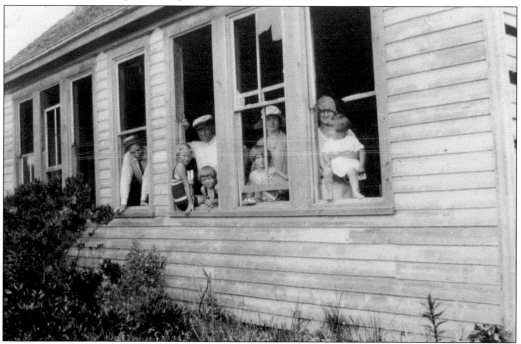

Taken from the Nichterlein family photo album, this photograph shows the lure of Tucker's Island despite continuing erosion. Members of the Nichterlein family stand in the remains of the old schoolhouse along with former schoolhouse teacher Florence Morse. (GH.)

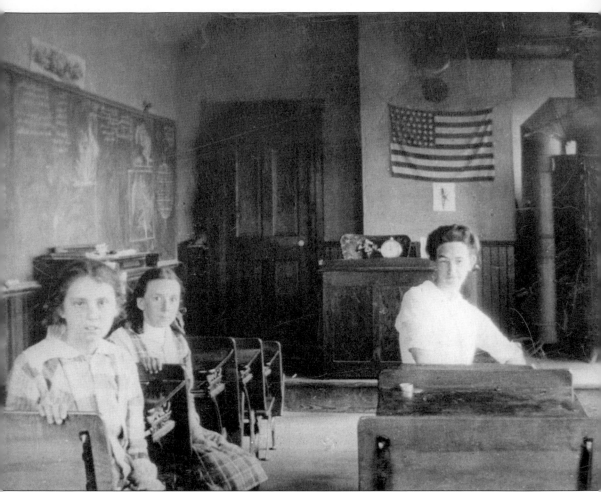

This interior photograph does not identify the children or teacher, but it is thought that the teacher is Florence Morse. In the classroom are a teacher's desk and double desks for the children. An American flag hangs on the wall behind the teacher's desk. A blackboard is filled with information for the children. The walls have tongue-and-groove cedar wainscoting. The little girls in this photograph have their long hair in braids and are dressed in jumpers. The children would have been of various ages, studying different subjects and comprising several grade levels. The first island fundraiser clambake raised an unprecedented $173 for the school; family members and friends from Tuckerton and Little Egg Harbor on the mainland attended, as did those from Beach Haven. With such a successful way to raise school funds, these clambakes were repeated every summer. Baskets of fresh clams were laid in beds of seaweed and eelgrass over a hot fire. (LBIHA.)

Reading was a favorite pastime both at school and in the early evenings. Without electricity, evenings usually ended early. Kerosene lanterns were placed on tables for nightly reading. These books were from the Sea Haven School, presumably brought to the mainland by a member of the Rider family. The top book is by Bryant & Stratton and is titled *Common School Bookkeeping*. It is a gray paperback, designed for a teacher's use only. The title of the second book in the stack is *With Lee in Virginia, A Story of the American Civil War*. Popular children's author G.A. Henty was born in 1832 and died in 1902. The other three books have been worn so that the titles, usually stamped in gold gilt, are completely gone. Arthur Rider spent a few summers in what had once been the schoolhouse; however, it had been moved to higher ground by that time. (THS.)

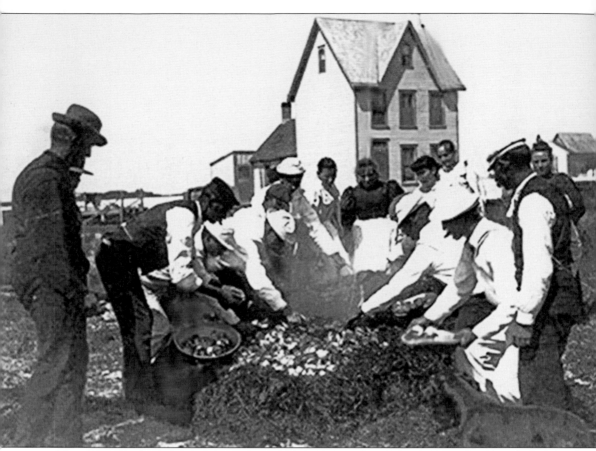

This photograph is captioned "Tucker's Island Clam Bake 1895." Eight men and six ladies are part of this enthusiastic group. The event was organized and the food prepared by Sea Haven community members. Clambakes were held to help raise funds needed to complete the school building and buy supplies. Clams are laid upon a high pile of steaming seaweed. At the time, clambakes were extremely popular in coastal communities and barrier islands along the Jersey Shore. Unfortunately, most local governments now prohibit them. In earlier days, money was scarce; administrators may have thought it a waste of money to build and staff a school on such a small island. A *Times Beacon* column of October 29, 1896, notes that "the school at Sea Haven has recently been favored with the addition of a handsome new organ, purchased with a part of the proceeds of the clambake. Our Sea Haven neighbors are certainly very enterprising and are making their school a model one." (LBIHA.)

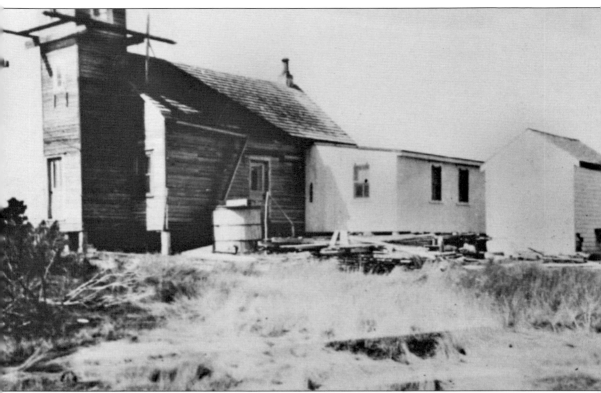

This is a side view of the Tucker's Island School. Shown is a drain spout leading from an uneven gutter into a wooden barrel that acted as a cistern. Water was collected on the roof. Inside, water was available from a pump. There was no fresh water on the island except what was collected on roofs and saved. There are no records of wells such as those found on Long Beach Island to the north. An outhouse is shown on the right-hand side of this photograph. Evelyn Suter wrote a speech for presentation at the Long Beach Island Historical Association, and the following is an excerpt from it: "The schoolhouse also served as a church and meetinghouse. I doubt if anyone here started his or her education in a more humble building. There were only six children going to school, and it was like a private school." (THS.)

In the 1870s and early 1880s, before the Tuckerton & Long Beach Railroad ran all the way down Long Beach Island to Beach Haven in 1885, it was a toss-up as to which resort—Beach Haven or Sea Haven—might succeed. The St. Albans and Columbia Hotels were advertising amenities such as telegraph facilities for businessmen, and this amenity was not yet available in Beach Haven. A real estate company called the Sea Haven Improvement Company was formed to sell lots. How can an ethical real estate company sell land that was clearly disappearing? Sadly, worthless land was sold to several unsuspecting investors who had never visited the site. As for Sea Haven, once the railroad came to Beach Haven in 1886, business quickly swung in favor of Long Beach Island's Queen City, where large Victorian "cottages" were built. (THS.)

Lots were for sale at the Philadelphia Exchange. The real estate on Tucker's Island was made to sound easily accessible—just a little railroad trip to Atlantic City or Tuckerton and a short boat trip by steam yacht to Sea Haven. In reality, the trip was a long and arduous one. (TF.)

The proposed development of Sea Haven was advertised as being located at "the south end of Long Beach, 10 miles north of Atlantic City." At the time, Sea Haven was connected to Long Beach Island and was a peninsula, not an island. Geared to attract people who might go to Sea Haven via Atlantic City, special round-trip fares were offered for $2 via the Camden & Atlantic Railroad and the Vine Street Ferry. (TF.)

Report – New Jersey. State Board of Assessors

STATE BOARD OF ASSESSORS.

NAME OF COMPANY.	Capital Stock.	Tax, one-tenth of one per cent.
Savoye Land Company	$9,000 00	$9 00
Schiff-Lewin Company	200,000 00	200 00
Schiller Mining Company	150,000 00	150 00
Scott & Bitting Paper Company	29,000 00	29 00
Sea Bright Improvement Company	75,000 00	75 00
Sea Bright Water-Supply Company	16,000 00	16 00
Sea Girt Land Improvement Company	489,200 00	489 20
Sea Haven Improvement Company of New Jersey	151,200 00	151 20
Sea Isle City Gas, Water and Sewerage Company	100,000 00	100 00
Sea Isle City Hotel Company	27,450 00	27 45
Sea Isle City Improvement Company	99,550 00	99 55
Sea Isle City Lot Association	22,460 00	22 46
Sea Isle City Lot and Building Association No. 1	460,000 00	460 00
Sea Isle City Lot and Building Association No. 3	50,000 00	50 00
Sea Isle City Lot and Building Association No. 4	50,000 00	50 00
Sea Isle City Turnpike Company	6,050 00	6 05
Sea View Land Company	66,500 00	66 50
Sea View Hotel Company	63,000 00	63 00
Seashore Construction Company	25,000 00	25 00
Seashore Electric Railway Company	200,000 00	200 00
Seashore Improvement Company	25,000 00	25 00
Seashore Land Company	72,000 00	72 00
Seaside Ice Company	40,000 00	40 00
Security Construction and Trust Company	100,000 00	100 00
Security Contract Company	8,000 00	8 00
Self-Storage Electric Light and Power Company	600,000 00	600 00
Selser Brother Company	25,600 00	25 60
Selvage Sewing-Machine Company	500,000 00	500 00
Seneca Lake Niagara Vineyard Company	60,000 00	60 00
Seven Mile Beach Company	953,370 00	953 37

65

The Sea Haven Improvement Company was registered to do business in New Jersey in 1890. Taxes on $150,000 worth of stock were $1 for every thousand dollars' worth of investment. Philadelphians involved in the railroad industry invested in Beach Haven, founded by Archaleus "Archie" Pharo. (NJMM.)

Annual Report of the State Board of Assessors of the State of New Jersey – New Jersey. State Board of Assessors

236 STATE BOARD OF ASSESSORS.

COMPANIES TAXED UPON CAPITAL STOCK—Continued.

Name of Company.	Capital Stock.	Tax.
Seacoast Canning Company,	$2,000,000 00	$2,000 00
Seacoast Hotel Company,	50,000 00	50 00
Seacoast Real Estate Company,	1,000 00	1 00
Sea Girt Company,	250,000 00	250 00
Sea Girt Land Improvement Company,	97,840 00	97 84
Sea Girt and Spring Lake Country Club,	13,600 00	13 60
Sea Girt Supply Company,	50,000 00	50 00
Sea Gull Specialty Company,	20,000 00	20 00
Sea Haven Company,	100,000 00	100 00
Sea Isle City Lumber Company,	5,300 00	5 30
Sea Isle City Ocean Pier and Amusement Company,	23,070 00	23 07
Sea Isle City Press,	2,500 00	2 50
Sea Isle City Publishing Company,	1,580 00	1 58
Sea Isle City Realty Company,	179,550 00	179 55
Seal and Moore Company,	25,000 00	25 00
Seaport Investment Company,	14,200 00	14 20
Searchlight Publishing Company,	1,000 00	1 00
Sea Shell Amusement Company,	2,000 00	2 00
Sea Shell Amusement and Land Company,	2,000 00	2 00
Seashore Building and Improvement Company,	10,000 00	10 00
Seashore and Husted Express Company,	9,000 00	9 00
Seashore Improvement Company,	25,000 00	25 00
Seashore Land Company,	72,000 00	72 00
Seashore Machine Works,	2,400 00	2 40
Seashore Navigation Company,	50,000 00	50 00
Seashore Novelty Company,	10,000 00	10 00
Seashore Publishing Company,	27,000 00	27 00
Seashore Realty Corporation,	4,000 00	4 00

In 1911, the New Jersey State Board of Assessors listed "companies taxed upon capital stock." At this time, the Sea Haven Improvement had $100,000 worth of stock with the state tax noted as $100. Was this because the land, which was the basis of the investment, was eroding away, or because the value of the land had diminished? It was probably a combination of both. (NJMM.)

Location, location, location—real estate agents have used this line forever. The Sea Haven Improvement Company of Walnut Street in Philadelphia was no different. Who would not want to own stock in a barrier island overlooking the Atlantic Ocean? However, it would have proven prudent if investors had seen the property they were purchasing prior to the transaction. (NJMM.)

Shares of stock in the Sea Haven Company of New Jersey were issued for $50 each and were "transferable only on the books of the company in person by attorney or surrender of this certificate." While this may have sounded good at the time, one must wonder how many shares in the company were actually sold. Little about the devastating effects of erosion was known in 1881 when this stock was offered. (NJMM.)

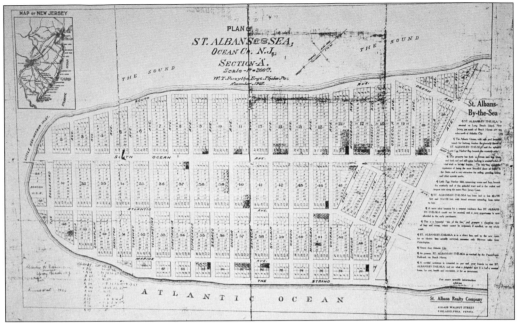

What was engineer W.T. Forsythe of Philadelphia thinking when he plotted Tucker's Island in 1907? His *Plan of St. Albans-by-the-Sea* in Ocean County contains miniscule lots on the south end of the island. Grids of 25 lots each are laid out. On the south end of the development, five lots are designated "Beacon US." This plot map shows the southern Division A. (NJMM.)

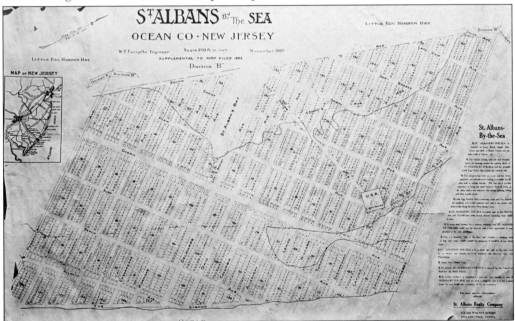

The northern half of the St. Albans development of lots is known as Division B, which wrapped around the lighthouse grounds. Certainly, developer Joseph Taylor should have known that his small-sized lots would never have worked on Tucker's. Several investors of both the Sea Haven and St. Albans-by-the-Sea real estate companies were executives of the Pennsylvania Railroad and the Baldwin Locomotive Works of Philadelphia. (NJMM.)

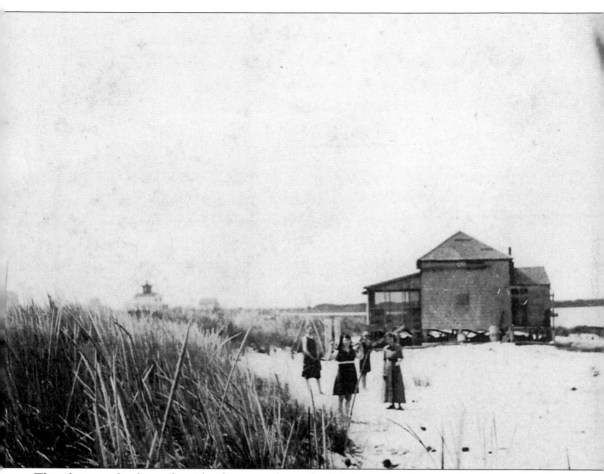

This photograph of a modest island cottage shows the lighthouse in the center background and the St. Albans Hotel (far left) and Columbia Hotel (center right) nearby. Note the young ladies ready for a day of fun, dressed in their sea bathing attire. Their fashion choices are daring for the time with skirts above their knees. In the background are the high dunes of the southern end of Beach Haven, connected at the time to Sea Haven by a slough, a wide path of sand and mud into which feet sank. For years, this would be passable. Eventually, an inlet would open up, making Tucker's Island an island once more. W.C. Jones of Tuckerton was co-owner of Skeeters, the vacation home of his wife and the Horner family on Tucker's Island. Luckily, his hobby was photography, for his photographs lend much insight into the lure of the island and the daily life of its inhabitants. (CE.)

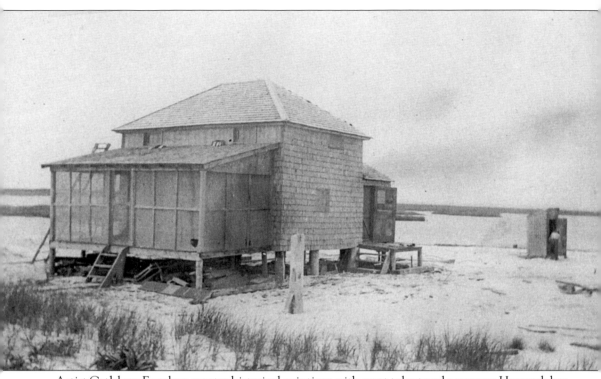

Artist Cathleen Engelsen creates historical paintings with great talent and accuracy. Her work has been shown and acclaimed throughout New Jersey. Could some of her artistic talents have been inherited from her grandfather W.C. Jones, who was a photographer? Cathleen paints history by attaching one of her grandfather's photographs to her easel. Her paintings of Tucker's Island take modern viewers back a century ago to a simpler life where families relaxed and enjoyed sailing, fishing, gunning, and soaking up nature. Cathleen Engelsen's website modestly claims that "Mrs. Engelsen is an Ocean County native with a deep appreciation of New Jersey's rich, historical background and its breathtaking coastal scenery." Cathleen has studied at the Samuel Fleischer Art Memorial, Philadelphia College of Art, and Stockton University. The authors are indebted to her for the use of her grandfather's photographs. (CE.)

Eight

GOING, GOING, GONE IN OCTOBER 1927

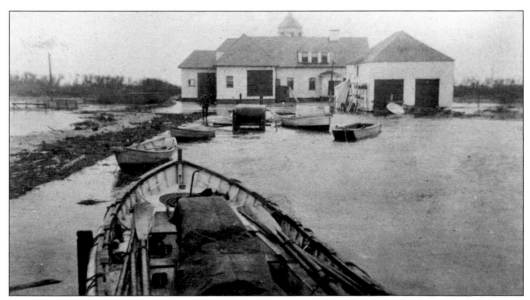

This is damage seen right after a winter storm in 1927. Taken from the back (west) side of the building, this photograph shows water almost surrounding the Coast Guard station. A walkway leading to the long boat dock has washed away. A lone Coastie walks from the building toward the dock, surveying the damage. (NJMM.)

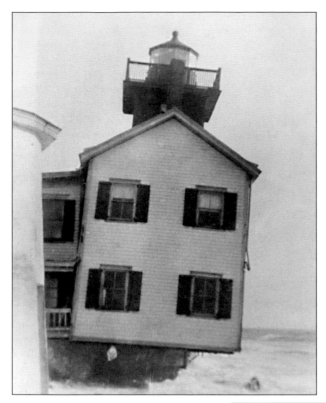

Paul Rider was the great-nephew of lightkeeper Arthur Rider and was the son of third-generation B. Rider and Mary Cox. He had been on Tucker's Island helping his Uncle Arth renovate the old schoolhouse for family use when they heard creaking and realized the lighthouse was going to fall over. Paul recorded this historic event with this set of photographs. (NJMM.)

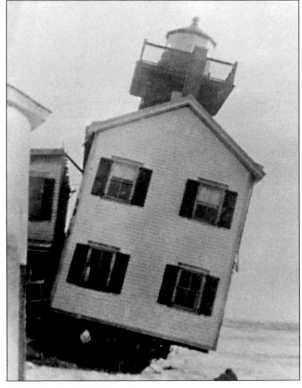

The first photograph in this series shows the lighthouse with a decided tilt. Water has completely washed under and around the front of the foundation. In this second photograph, the front and back have separated, leaving the front falling and the back still standing. The original lighthouse, which had been converted to an oil house, remains intact. Paul Rider took these photographs with his Brownie box camera. (NJMM.)

This photograph shows the lighthouse falling into the Atlantic Ocean. Part of the tower railing is in midair, but the tower has not come apart. When the lens was installed in the lighthouse, its iron framework was bolted to the pedestal. The pedestal was bolted to an iron grate fastened to the oak floor. The fate of the Fresnel lens remains a mystery. (NJMM.)

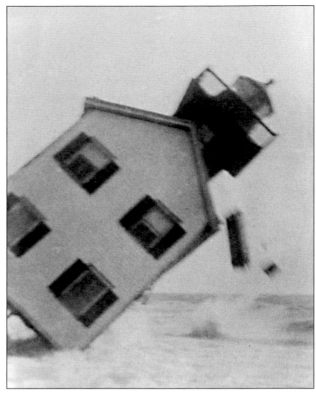

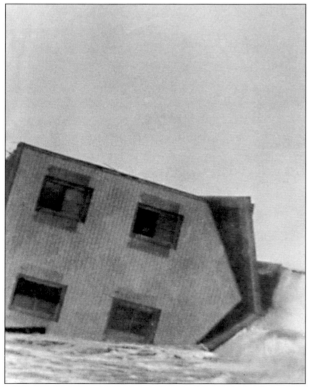

In this photograph taken a day or so later, the lighthouse has settled into the sand. The front porch is missing, as are the shutters. Waves wash around the building. Paul Rider was a civil employee at the naval air station. He lived most of his life in Tuckerton; Paul died at age 75, leaving two daughters, three grandchildren, and four great-grandchildren. (NJMM.)

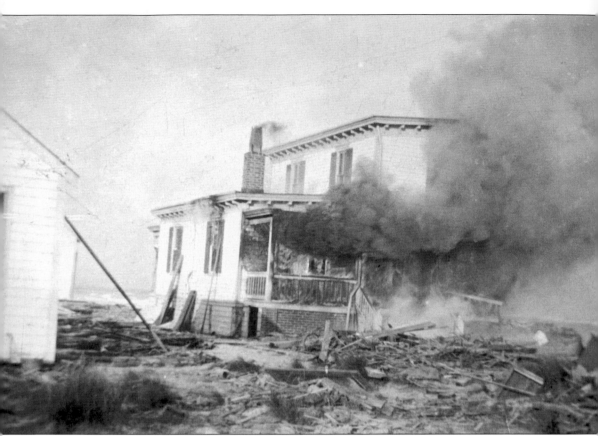

After the front half of the lighthouse fell into the sea, the back half was left standing. From this picture, it is obvious that this part of the residence burned. The circumstances surrounding this fire will never be known. An October 1927 article in the *Times Beacon* states that the furniture and Fresnel lens were removed; but this statement may be the opinion of the writer. Maritime historians become confused when deciphering Tucker's Island information. Logs are intact and not questioned, but newspaper articles about the time period differ as to island facts. So much of Tucker's Island information has been handed down from generation to generation that memories may not be accurate: Perhaps something sparked after the two parts of the building separated, setting the fire; or a bystander could have torched the remains; or the order could have come from the lighthouse inspector instructing the US Life-Saving Service to burn anything still standing. (THS.)

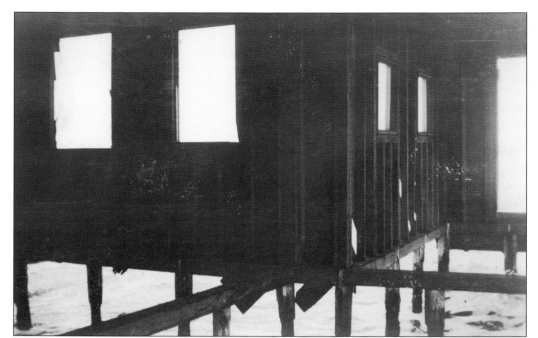

By 1933, erosion had taken its toll on the Coast Guard station. Windows and floors have washed away, leaving only a few walls in place along with the old cedar pilings that had been used in parts of the building. All belief that the island could be saved had vanished along with the buildings and sand underneath them. (GH.)

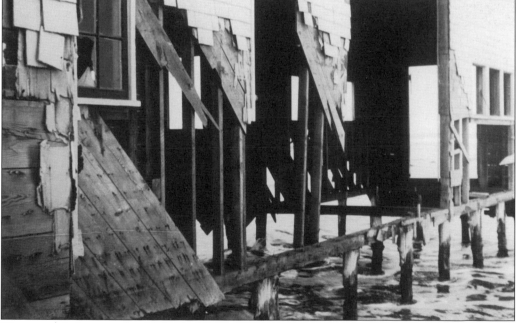

This is a sad photograph of the Coast Guard station, destroyed by continual erosion and storms during the winters of the early 1930s. Walls had been knocked out by waves and wind. A window is shattered here, others gone along with doors. Cedar shakes, original to the building, remain above the water level. A once thriving island was quickly disappearing. (GH.)

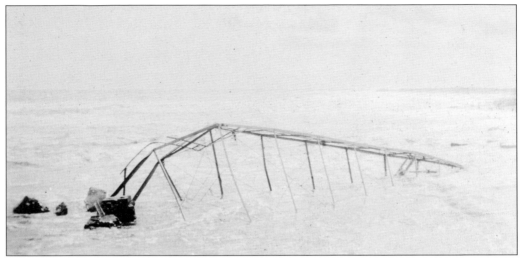

A structure, looking like a cross between a snow fence and walkway, was placed on its side on the Coast Guard station beach. It is thought to have been designed and placed there by the Army Corps of Engineers. The "fence" was put in place by driving narrow cedar poles deep into the sand. However, it only lasted a year. A bad nor'easter destroyed the structure; water washed under the wood, uprooting the posts. (GH.)

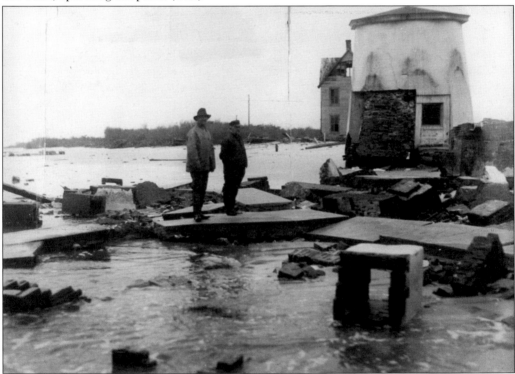

Former lighthouse keeper Arthur Rider (right) must have been devastated, surveying the wreckage of the lighthouse around him. The building is gone—the front half in the water and the back half burned to the ground. He is standing with an unidentified man on the remains of the concrete walkway leading from the lighthouse. Part of the oil house wall is gone, revealing the original light structure beneath. (LBIHA.)

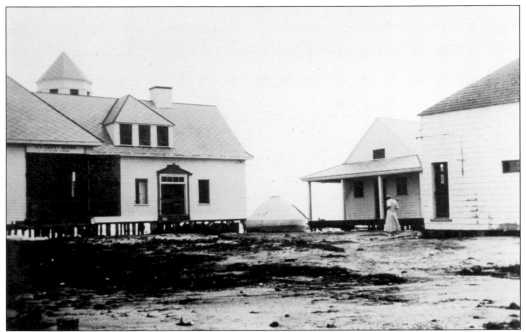

The Coast Guard building and outbuildings were completely destroyed by 1934. Only a few walls remained. But the pull of Tucker's Island was still strong. In this photograph, a young lady is snapping a picture of the deserted building. The saga of Tucker's Island has piqued the imaginations of people from as far away as Cape May, Toms River, and even Philadelphia. (GH.)

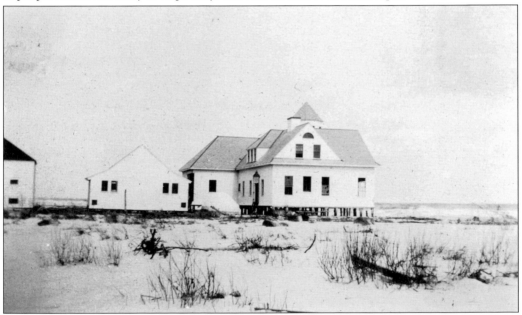

In this photograph, sand has disappeared from around the Coast Guard building. All vestiges of greenery around the site have disappeared. Water has continually washed under the building. Windows, boats, and small outbuildings are gone. No one could imagine the difference between hydrographer Edmund Blunt's 1822 chart of Tucker's in his *American Coastal Pilot*, where he shows a house and three trees, and the island in 1934. (GH.)

A sequence of aerial photographs shows the progression of destruction as nor'easters and hurricanes pounded the island. From 1932 to 1944, the deserted island continued to erode. Summer picnickers proceeded to explore the island; on each visit, there were less signs of former habitation. Buildings disappeared one by one, battered by storms. Walls, windows, and footings all washed away. This photograph was taken in 1932. (NJMM.)

In just one year, the size of the island had diminished greatly. The northern part (center in bay) of Tucker's Island had broken off. Beach Haven Inlet was forming. This inlet was shallow at first; sandbars and waves are visible. Yet this official Coast Guard photograph has Beach Haven Inlet written in over the water between Tucker's and Long Beach Island. This photograph was taken in 1933. (NJMM.)

John Bailey Lloyd writes in *Eighteen Miles of History* that "at a meeting on the evening of Nov. 8, 1932, the governing body of Long Beach Township (NJ) ordered its tax assessor to remove from the books 'that portion of the Township south of the new inlet at Beach Haven known as St. Albans-by-the-Sea, as it has practically washed away by the ocean.'" Officially at least, the island ceased to exist. (CDR Timothy Dring and NJMM.)

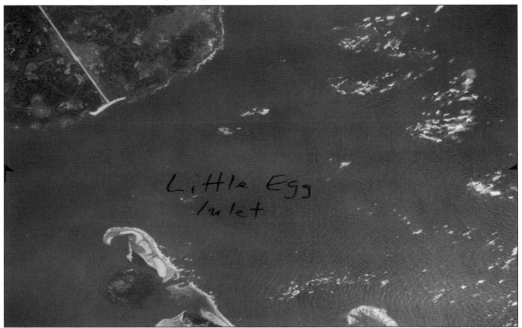

Little Egg Inlet is marked in black marker on this 1934 photograph. Everyone was gone from the island except for curiosity-seekers or nostalgic former residents. The Coast Guard contingent of 12 men had been moved to the Maryland Avenue, Beach Haven Terrace Station, almost 10 miles north on Long Beach Island. (CDR Timothy Dring and NJMM.)

Beach Haven Inlet and Tucker Island (note the spelling) are written on this c. 1933 aerial photograph. During the 1930s, Coast Guard planes routinely photographed the Jersey Shore, a practice still followed today. There was originally almost 1,500 feet between the lighthouse and the ocean. This completely disappeared between August 1848 and November 1921. During the 1930s, there was little mention of Tucker's Island. The Great Depression brought out more important concerns. (CDR Timothy Dring and NJMM.)

This 1944 aerial shows a wide Little Egg Inlet and a smaller Beach Haven Inlet. Both were navigable. While Tucker's Island is diminishing, the mainland marshes have not changed. A road leading from Tuckerton to the new Little Egg Coast Guard Station is marked in white. To the left is Little Beach, where Coast Guard Station No. 120 stood. Long Beach Island is visible in the right side of this picture. (CDR Timothy Dring and NJMM.)

Nine

SHIPWRECKS OFF THE JERSEY SHORE

How proud the people of Camden, Maine, were when the *Helen J. Seitz* was launched. Built by the Holly M. Bean Shipyard and named after the wife of Arthur Seitz, vice president of Coastwise Transportation, this five-masted schooner was a rare beauty. She was launched on October 30, 1905, measuring 308 feet in length and 38 feet wide, with a 48-foot depth. She went aground near Tucker's Island on February 9, 1907. (NJMM.)

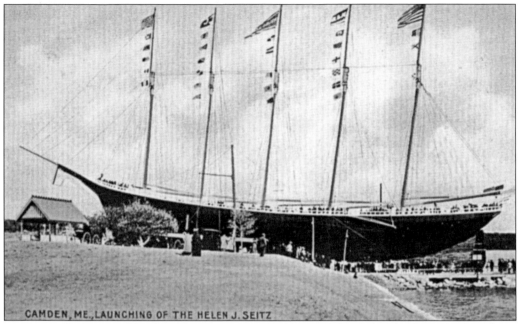

CAMDEN, ME., LAUNCHING OF THE HELEN J. SEITZ

Five-masted schooners like the *Helen J. Seitz* were built toward the end of the days of sailing ships, from around the late 1800s through 1915. They were built as cost-cutting ships and were sailed on ocean passages throughout the world and along the US coasts. By 1910, some 45 five-masted schooners had been built, mostly in Maine. (NJMM.)

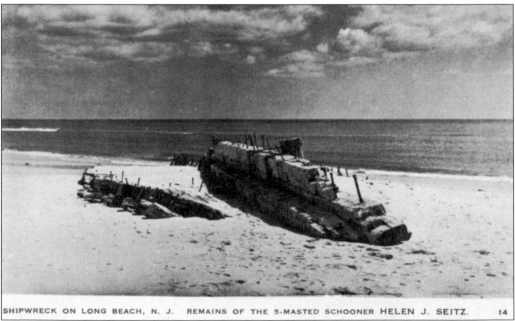

SHIPWRECK ON LONG BEACH, N. J. REMAINS OF THE 5-MASTED SCHOONER HELEN J. SEITZ. 14

The remains of the majestic *Helen J. Seitz* lay in the sand about one half mile off the southern end of Long Beach. She went aground just north of Tucker's Island on February 9, 1907, loaded with a cargo of soft coal. The ship was on the way from Baltimore to Boston. The value of the ship was estimated to be $100,000; her cargo, $20,000. In spite of valiant efforts by US Life-Saving crews, she could not be refloated. (NJMM.)

This bell from the *Cecil P. Stewart* belonged to keeper Arthur Rider. It was common for lifesavers from one station to help others to their north or south. Rider assisted in the attempted rescue of the four-masted brigantine on February 7, 1827. Dunn and Eliot in Maine built this ship for the Lyman Morse Company in 1919. (Photograph by Shannon Weaver Photography, courtesy of NJMM.)

On the back of the handbell from the *Cecil P. Stewart* is a drawing of four masts looming out of the black ocean. It was donated by Rider descendant Shirley Whealton of Tuckerton, and it is thought that keeper Arthur Rider later painted on the back what he literally saw—four masts. The *Cecil. P. Stewart* carried a cargo of railroad ties. (Photograph by Shannon Weaver Photography, courtesy of NJMM.)

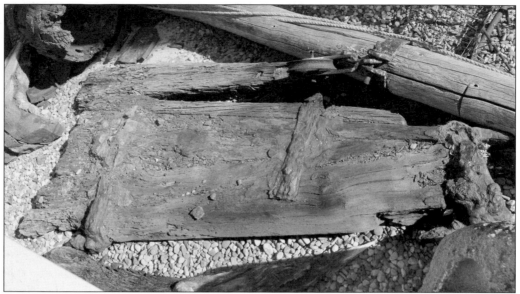

Divers recovered the rudder from the clipper *Ontario*. The New Jersey Maritime Museum Shipwreck Database lists the value of the ship at $60,000 and the value of its "general cargo" at $100,000; but Captain Bond of the Bond's Station just above Tucker's Island thought it was worth more. He described locating the ship by lantern and finding the crew had left in the *Ontario*'s own lifeboats. (Photograph by Shannon Weaver Photography, courtesy of NJMM.)

The anchor from the *Ontario* sits on the lawn outside the Long Beach Island Historical Association in Beach Haven. Deb Whitcraft, who, along with Bob Yates, recovered it from the site, donated it in the early 1980s. The British bark *Ontario* was sailing from Liverpool, England, to New York when she went aground. (NJMM.)

New Jersey divers have been extremely generous to the New Jersey Maritime Museum, providing artifacts that illuminate New Jersey's rich maritime history. An unidentified bronze spike was recovered from a local wreck site. It is believed that over 5,000 shipwrecks occurred off the Jersey Shore. Most are now detailed in the NJMM Shipwreck Database available on the museum's website. (NJMM.)

This soap dish is from a wreck off Long Beach Island. Before the 1900s, the best way to get up and down the East Coast was by ship. Passenger service ships had regular routes transporting families and businessmen from city to city. Ships kept close to the coastline to aid in their navigation, spotting beacons along the way. (Photograph by Shannon Weaver Photography, courtesy of NJMM.)

These two pistols are from a wreck off Brigantine. Tucker's Island was two stations north of the Brigantine US Life-Saving Station, with the Little Beach Station in between. Often, two or three Life-Saving stations worked together during a difficult rescue attempt. During bad storms, many wrecks occurred at the same time. Many vessels met their fate after striking the hulls of former wrecks. (Photograph by Shannon Weaver Photography, courtesy of NJMM.)

This sword is from an unidentified shipwreck located off the southern tip of Long Beach Island. It is a European enlisted man's cavalry saber from around 1830 to 1850. It was not for US civilian or naval use. It was most likely part of a shipment of European imports bought for use by a myriad of private state militias that were outfitted with European arms. (Photograph by Shannon Weaver Photography, courtesy of NJMM.)

Ten

A NEW BEGINNING OF STATION NO. 119

The former Little Egg Harbor US Life-Saving Service Station No. 119 is passed by boaters traveling the Intracoastal Waterway, Little Egg or Beach Haven Inlets, Great Bay, and the Mullica River. Built in the mid-1930s, it is sometimes referred to as the "new" Little Egg Station. After being abandoned in 1950, the station was turned over to the General Services Administration in 1964 and was subsequently sold to Rutgers University. (GC.)

The white station buildings have red roofs and include a short eight-sided tower. To the left are the original boat docks. The boathouse is on the right. In the distance is the deserted Crab Island Fish Factory. A cedar-planked road leads out across the right. This restored site now houses the Rutgers University Marine Field Station. Rutgers University has restored this Coast Guard station, maintaining the historical significance of Station No. 119. (GC.)

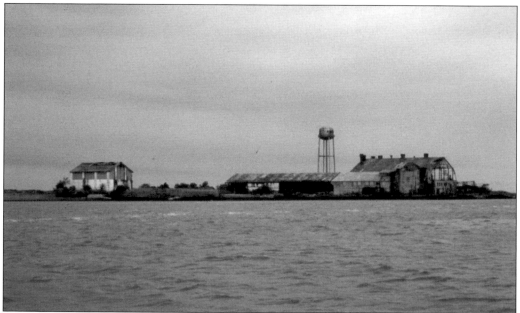

The Crab Island Fish Factory was built in 1930 and was one of a number of fish processing plants along the mid-Atlantic coast. Menhaden, or bunker, abundant along the Jersey coast, were considered too oily for eating, and created a disgusting, odorous mess when processed. Local men from Tuckerton and the Mullica River areas worked on Crab Island in full view of Tucker's Island. (GC.)

A patrol boat from the Little Egg Harbor Life-Saving Station in Tuckerton keeps guard off of the Holgate section of Long Beach Island. Little Egg Inlet, because of its width and depth, was seen as seriously threatened by German submarines that were often sighted off Long Beach Island. There were troops stationed on Long Beach Island, and blackout rules were enacted along all of the New Jersey coast when the United States entered the war in 1941. (GC.)

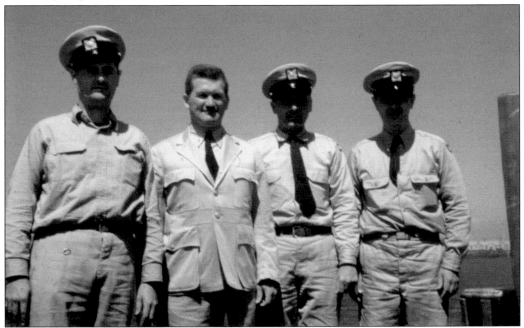

Unidentified officers of the Little Egg Harbor Flotilla of the Coast Guard Auxiliary stand on the dock at the Little Egg Harbor Yacht Club. While they took their jobs very seriously, there was also much camaraderie and fishing off of Tucker's Island. These men formed the last group to walk on Tucker's Island on a regular basis. (GC.)

Wesley M. Heilman Sr. was a founding member of the Little Egg Harbor Flotilla in 1942. Men assembled on B Dock at the Little Egg Harbor Yacht Club in Beach Haven, and access to the dock was forbidden to anyone except the Coast Guard Auxiliary. On his first day of patrol, Wesley Heilman found an empty Norwegian lifeboat from a ship that was sunk five miles off Barnegat. (GC.)

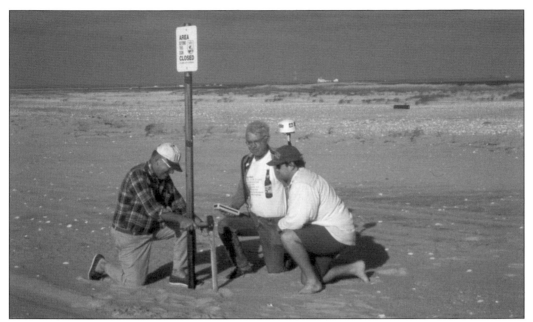

Eighty-eight years have passed since the Tucker's Island lighthouse fell. In 1995, while researching an article on the lighthouse, coauthor Gretchen Coyle decided to pinpoint the exact location. The coordinates were obtained from an old book of lighthouses and Life-Saving stations along the New Jersey coast: latitude 39 degrees, 30 minutes, 19 seconds north; longitude 74 degrees, 17 minutes, 9 seconds west. (GC.)

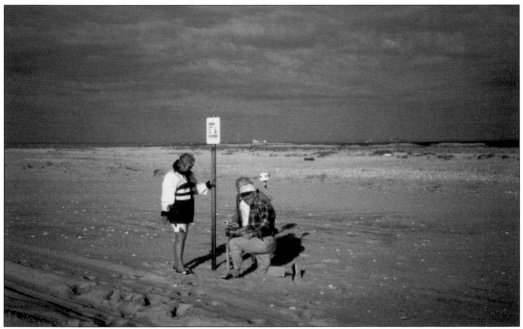

Coauthor Gretchen Coyle holds on to a marker at the Edwin B. Forsythe National Wildlife Refuge, which marks a nesting area. Jim Stevens (right) and John Coyle mark the site of Tucker's Island Lighthouse, finding it to have been east of where the refuge is now located, approximately a half mile north of the refuge's southern tip. (GC.)

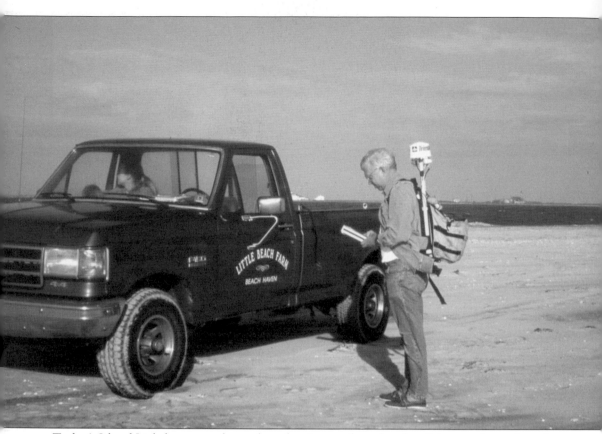

Tucker's Island Lighthouse was located at what is now three fourths of the way down the refuge and a short distance out in the ocean. Could the Fresnel lens to Tucker's Light still be in the Atlantic, or did the Coast Guard or local residents take it in September 1927? No sign of the Fresnel lens has ever surfaced, leaving it to be one of the island's unsolved mysteries. Jim Stevens is pictured here. (GC.)

Evelyn Suter sits at her desk in her home on Route 9 in Parkertown. Built in 1906 by her bayman father, Ralph Gowdy Cummings, the house is appropriately named Sea Haven. Evelyn was six years old when her mother and father first went to Sea Haven. Ralph had signed on as a lifesaver for the months of September to May. Wrecks occurred predominantly in months when storms were most frequent, from late fall through early spring. The family would then return for the summer to Parkertown where her father clammed. "The Life-Saving station and the lighthouse did a great service in saving lives," Evelyn told an audience in the 1970s. "Really brave men." She remembered every detail of the island, citing it as the happiest time in her life. She recalled, "Six bungalows housed the men and their families. There was a minister (Reverend Dill) who had a home down at the inlet, a summer home." Evelyn continues with her memories: "There was a horse name Harry who pulled the boats to the beach when the men went out on a rescue. I met Harry one day as I was coming home from school on a narrow path, and I was frightened. I took refuge in the bayberry bushes. There was quicksand on the island; a team of horses went down in it in the 1800s. There was one very near the path I took to school. My father was 28 when he signed on as a lifesaver, and my mother, Martha Horner Cummings, was 26. We were assigned to a small pink bungalow, which had a rain barrel to catch water. The second year we couldn't have the bungalow, so father bought a large houseboat, *Independence*." Ralph Cummings towed the houseboat to the island in a horrible storm. (GC.)

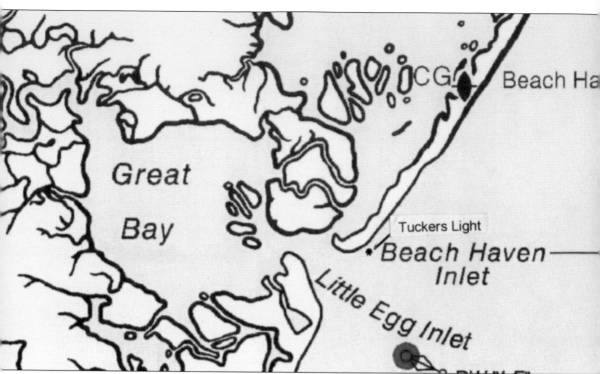

It is difficult for Tucker's Island aficionados to understand today where the island was located. People just assume it was west of the Edwin B. Forsythe National Wildlife Refuge; nothing could have been further from the truth. Case in point was a sandbar that popped up a dozen years ago just west of the southern tip of the refuge; everyone, including the press, referred to this sandbar as Tucker's Island. Since it was not connected to the refuge, with its stringent rules, boaters enjoyed picnics with families and dogs. In a few years, the sandbar was absorbed into the end of the Forsythe Refuge, and completely forgotten. Over the past 50 years, the refuge has elongated about two miles, and slants to the west from years of erosion from the east. The dot on this map shows the location of where the Tucker's Island Lighthouse stood—almost to the end of the refuge about one-eighth of a mile out into the ocean. (NJMM.)